IMAGES
of America

SOUTH RIVER

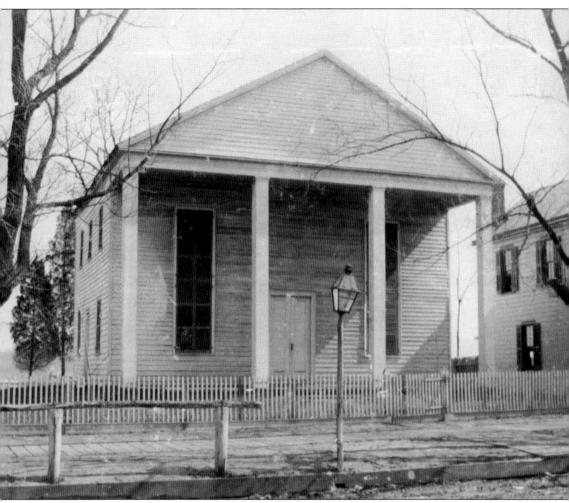

The South River Museum building, erected in 1805, is shown here on April 16, 1894, in its original incarnation as the Old School Baptist Church. It served as the public library from 1923 until 1979 and then housed the office for the borough clerk. After extensive restoration, it opened as the South River Museum on September 12, 1999. (Courtesy of the South River Historical & Preservation Society, Inc.)

ON THE COVER: The newly expanded Washington School No. 1 is shown here on May 2, 1896. The cornerstone for the center section, the original building, was laid in 1884. The first high school class, all female, graduated in 1893. Jesse Selover became the first male graduate of the high school a month after this photograph was taken. (Courtesy of the South River Historical & Preservation Society, Inc.)

IMAGES
of America

SOUTH RIVER

Stephanie Bartz, Brian Armstrong,
and Nan Whitehead

ARCADIA
PUBLISHING

Published by Arcadia Publishing
Charleston, South Carolina

Printed in the United States of America

Library of Congress Control Number: 2014945848

For all general information, please contact Arcadia Publishing:
Telephone 843-853-2070
Fax 843-853-0044
E-mail sales@arcadiapublishing.com
For customer service and orders:
Toll-Free 1-888-313-2665

Visit us on the Internet at www.arcadiapublishing.com

Dedicated to the memories of Dick Meyers and Earl Wenger,
who inspired us and made us all better historians

CONTENTS

ACKNOWLEDGMENTS

We appreciate the confidence that the South River Historical & Preservation Society has shown in us by trusting that we could make our often-discussed dream of a South River book a reality. The photographs we have included are taken from the Van Dyke Reid Collection at the South River Museum and have all been made available courtesy of the society.

Our gratitude extends to Richard Van Dyke Reid for his foresight in preserving history through his scrapbooks and amazing photographs and enabling us to see the past through his eyes. His legacy provided the foundation for this book. If we could only step back in time, we might have his help in solving some of the remaining mysteries about South River history.

An additional thank-you goes to the late Harold Armstrong for being the gatekeeper to this priceless collection of South River history. Ensuring that these photographs were returned to their home was a wonderful gift. His valuable donation has provided one of the cornerstones of the collections at the South River Museum.

A very special thank-you goes to Ed Bartz for providing an outsider's perspective and telling us that this book would be more interesting if it intermingled the images to show the footprint of South River in the late 1800s and early 1900s. From his idea, we created a road map that our readers will be able to follow. Each chapter uses Reid's photographs of the streets to establish a path readers will be able to walk as they read about the houses, churches, businesses, people, and other points of interest along the route.

The coauthors would also like to thank Ed Bartz for being a sounding board for Stephanie and for sharing her with our committee. Without her, we would not have this incredible book.

We hope that you will enjoy contemplating South River's history through this book as much as we have and perhaps walk the trail we have provided.

INTRODUCTION

South River's roots date back to 1720, when the first Willett settled in the area that eventually developed into the present-day borough. Although Wall and Pickersgill's *History of Middlesex County, New Jersey, 1664–1920* indicates that the community was renamed in honor of George Washington around 1784, Willetstown is the name that appears on the 1811 *Map of the Country Thirty Miles Round the City of New York*. Regardless of the names ascribed to the borough during the 18th century and the majority of the 19th century, the New Jersey legislature officially changed the name from Washington to South River in 1898, when it passed an Act to Incorporate the Borough of South River, in the County of Middlesex.

In the earliest years of New Jersey's history, the area that became South River was part of the province of East Jersey. Middlesex County was established in 1683, and when it was divided into three townships in 1693, South River's lands became part of Piscataway. It was not until more than 100 years later, in 1798, that the township of North Brunswick was incorporated and the village of Washington included as part of it. When East Brunswick was formed from parts of North Brunswick and Monroe township in 1860, the village again had a new allegiance. A decade later, the boundaries of the village were defined, although still within East Brunswick township, and a separate board of commissioners was established. South River came into its own when it finally separated from East Brunswick in 1898.

Born in September 1833 in what was then the village of Washington, Richard Van Dyke Reid established himself as an unofficial local historian at an early age. The son of John R. Reid and Martha D. Snedeker, he was the second of five children. His two brothers died before their first birthdays, and his mother died in 1853. He married Sarah H. Van Schoick, and in 1858, two years after his marriage and the establishment of Washington Monumental Cemetery, had his two brothers and mother moved from their burial places in Spotswood and reburied in South River. He outlived not only his parents and his two brothers, but his two sisters, his wife, and their only child, Eva May Reid Brown.

Reid collected information on marriages, deaths, township and borough elections, school trustee elections, church events, and other items that related to South River, Red Bank, and surrounding communities. The earliest dated item in his scrapbooks is his handwritten record of the passing of "Grandma" Reid on July 31, 1844, when Reid was just 10 years old. His record of marriages begins with a section labeled "Years Unknown." The first with a recorded date is the marriage of Robert M. Taylor and Caroline E. Poole on November 24, 1847.

Even Reid's political interests dated back to his youth. The "Township Whig Ticket" of April 1846 begins his chronicle. Although several of the names, such as that of Jonathan Booraem, have a definite connection to South River, the record dates from the period when the village of Washington was still part of North Brunswick township.

In March 1851, at age 17, Reid surveyed and drew what is now the oldest known map of the village where he was born. It details not only the bend of the river and the streets of the time, but also buildings and plots of land along with the names of their owners. The Old School Baptist Church, now the South River Museum, and the district school next door are both marked.

The scrapbooks continued to expand while Reid attended Rutgers College, graduated, married, raised his daughter, and established his career. He lived, at various times, in South River, Shrewsbury, and Red Bank. His occupations included teacher, school principal, partner in a mercantile business, purser on a steamer, and bookkeeper. He also served as a census enumerator, town clerk, secretary of the board of health, church trustee, assistant postmaster, and Sunday school superintendent.

In the 1890s, Reid developed an interest in photography. A July 1892 newspaper notes that "R. Van Dyke Reid of Red Bank is taking much interest in amateur photography, and has become quite expert in taking out-door views." He continued that interest when he moved back to South River following the death of his daughter, five months after the article appeared.

Reid's photograph collection spans the period from 1891 to 1907. Although the photographs are predominantly of South River, the collection also includes images of Red Bank, New Brunswick, Sayreville, Milltown, South Amboy, Morristown, Matawan Station, and Newark, as well as views of sites like Governors Island and Ellis Island. Interestingly, one of the earliest photographs in the collection shows the central monument at South River's Washington Monumental Cemetery, and one of the last photographs in the collection captures an almost identical view.

Richard Van Dyke Reid's legacy provides a unique view of South River during its transition from a village within North Brunswick township to its inclusion in the newly established township of East Brunswick and continuing to its emergence as an independent borough. No other single resource provides such an extensive portrait of South River's history.

Later historians include Jesse Selover, who wrote the unpublished three-volume "History of South River, New Jersey," which was completed by his wife, Jean Armstrong Selover, after his death in 1958. Paul A. Schack subsequently authored the 1970 booklet entitled *History of South River*. His collected materials on South River history are located in Special Collections and University Archives within the Rutgers University Libraries.

The South River Historical & Preservation Society took up the task of preserving the borough's history in 1988. The portraits of the Willett sisters that were the impetus for the creation of the society are an important part of the museum collections, as are the map, photographs, and scrapbooks created and compiled by Richard Van Dyke Reid. The showpiece of the South River Museum is the monument carved by well-known American sculptor John Frazee and dedicated "To Jane, the wife of my youth," who died in 1832.

The South River Museum, the home of the South River Historical & Preservation Society since 1999, is often still referred to as the library or the War Memorial Building, thus reflecting its significance in the memories of borough residents. The society not only collects and stores materials related to South River's long ago and more recent past, but also serves as steward for the museum building in order to preserve the past for future generations.

One

UP FROM THE RIVER

Richard Van Dyke Reid, born in South River in September 1833, had a varied career in the community. Among the positions he held were teacher, merchant, census enumerator, secretary of the board of public health, assistant postmaster, and superintendent of the Methodist Episcopal Sunday school. He was also the photographer of the images included in this collection. His portrait was taken in New Brunswick in March 1898 by a Mr. Dickinson.

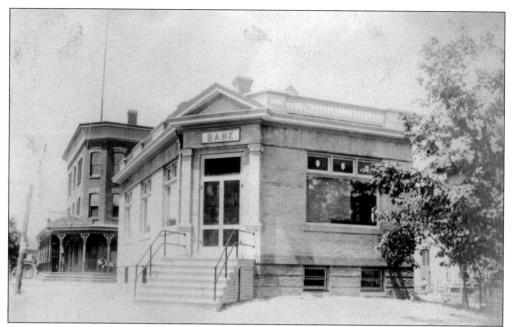

The First National Bank of South River, shown here on July 11, 1902, was at the corner of Main and Reid Streets. Completed less than a month before it was photographed, the bank remained at this location until the new building at the corner of Main and Stephen Streets opened in January 1916. The American Hotel on Reid Street is visible behind the bank.

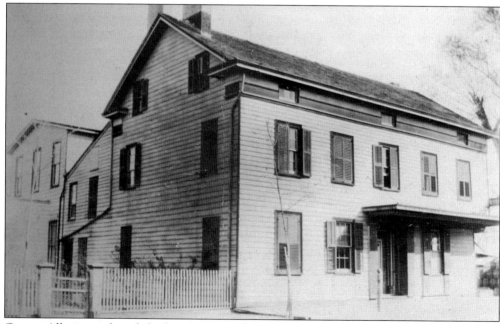

George Allgair purchased the house previously owned by John R. Reid and converted it into the Steamboat Hotel. There was a bar on the first floor, and the Allgair family occupied rooms on the second floor. Photographed on November 2, 1894, it burned to the ground on May 1, 1896, about six years after it opened. When the ashes settled and the insurance money was paid, Allgair rebuilt.

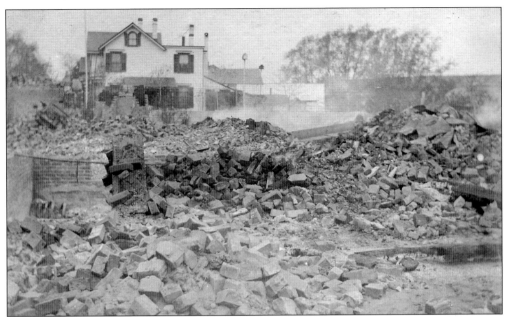

On May 1, 1896, fire at the Steamboat Hotel on Reid Street completely destroyed the building, as well as a stable on the nearby Hoffman House property. The glass in the front of Jacob Levinson's cigar manufactory across the street was also broken. Paul Tschumpher, an employee of Herrmann, Aukam, and Company, died in the fire. The hotel's first floor included the barroom, kitchen, dining rooms, and parlors. The second story had sleeping apartments and meeting rooms for local civic groups. The damage was estimated at $10,000, including items that belonged to the civic organizations that used the meeting rooms. These included the Improved Order of Red Men, the Knights of Honor, and the Lady Knights. The image above displays the destruction, with the home of William H. Peterson to the north. The view below looks southeast toward Main Street.

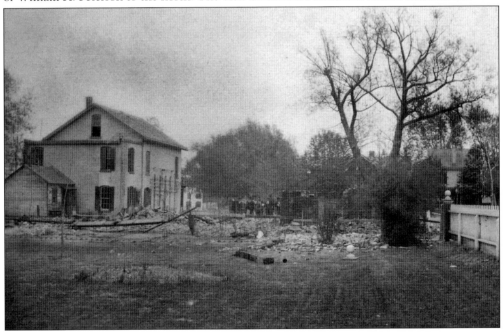

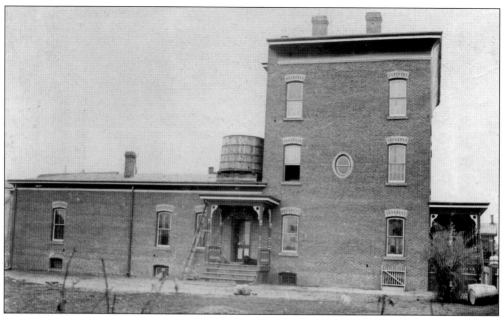

When George Allgair rebuilt his hotel after the 1896 fire that destroyed it, he renamed it the American Hotel. Like the original building, it included hotel rooms, a saloon, and meeting rooms. The side view of the hotel, above, was taken on March 18, 1897, less than a year after the fire that destroyed the original building. The photograph below features the hotel from the Reid Street side on October 25, 1904. The outbuildings on the river side of the hotel included a coal shed, an icehouse, and a beer bottling plant. Allgair had his own trademark for use on the beverage bottles and delivery boxes. By 1920, the large meeting rooms in the hotel were converted into the Noxall Waist Company. The hotel was later owned by the Sobolewski family and torn down on June 2, 2000.

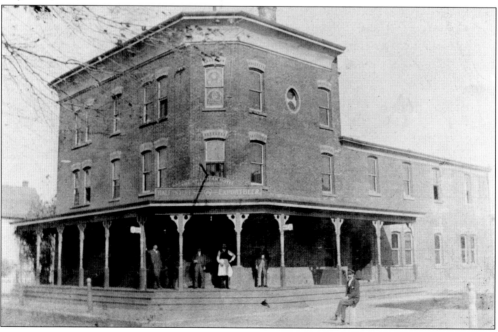

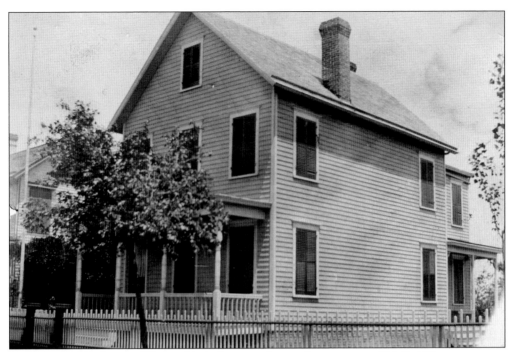

In the late 1800s, George Allgair added a house to the northwest corner of his Reid Street property and moved his family out of the hotel. They continued to reside in the house even after the hotel was sold. Photographed on June 16, 1899, the house has survived into the 21st century.

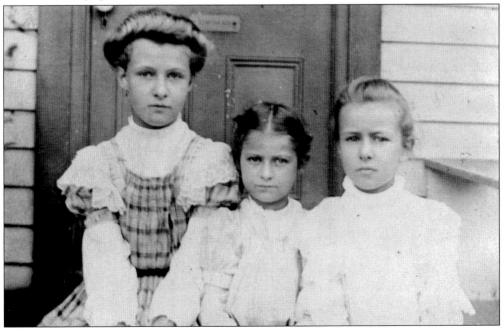

Pictured here on August 5, 1901 are, from left to right, Lucy Allgair, Pauline Allgair, and Edna St. John, whose family came from New York to visit the Allgairs. Lucy and Pauline were the daughters of George and Mary Allgair, proprietors of the American Hotel. The Allgairs also had two sons, William and George.

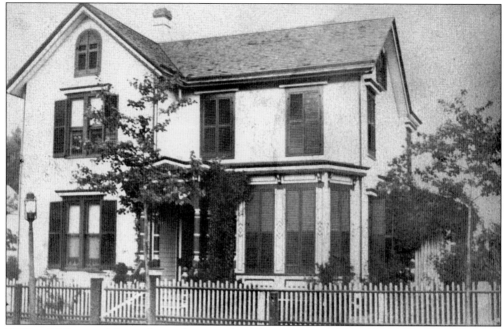

William H. Peterson's home, located next to the Allgair property on Reid Street, was photographed in August 1895. Peterson was a brickmason and a farmer and one of the few residents of South River who hired and housed African American workers. In the 1870 census, 18-year-old Edward Harris is identified as a farm servant, and 23-year-old Towsend R. Hicks is similarly identified in the 1900 census.

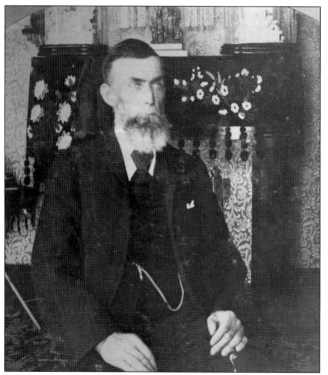

William H. Peterson was married to Mary Frances Reid, sister of R. Van Dyke Reid and daughter of John R. Reid. Pictured here in his parlor on November 4, 1894, Peterson was a brickmason by trade, although he also farmed and partnered briefly in a mercantile business with his brother-in-law. Martha Peterson, his only child, married Julius Kleine, also of South River.

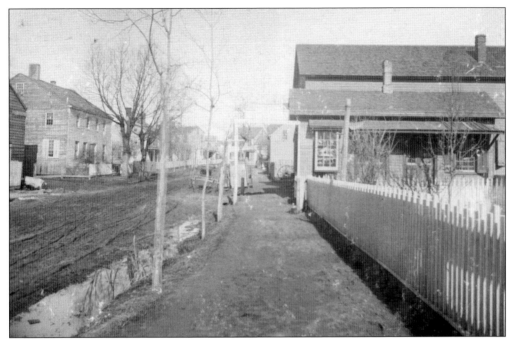

Taken on March 13, 1893, this early view of Reid Street shows the perspective from near the William H. Peterson house, directly across from George Street, looking north toward the bend. The building in the right forefront is Gustav Wall's harness shop. John Whitehead's brickyard is at the bend in the road.

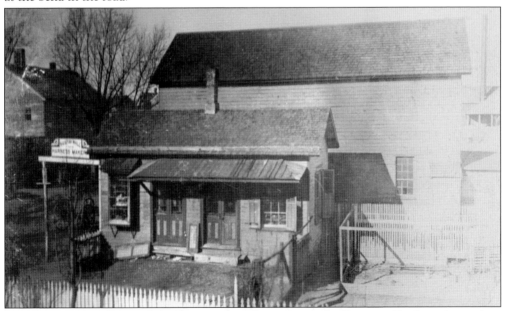

Gustav Conrad Wall owned this harness shop, located near the Booraem Brothers shipyard on Reid Street. He was born in France but lived most of his life in South River. Prominent in the community, Wall owned a house on Washington Street, near Gordon Street, and lived with his wife, Emilie Schreiber, and other family members until his death in 1907. The photograph was taken on June 6, 1896.

The view in this January 19, 1899, image of Reid Street looks south toward Main Street from the bend. A portion of the American Hotel is just visible in the distance on the left side of the photograph. The building in the background is the Union Hotel on Main Street, owned by the John Eppinger family.

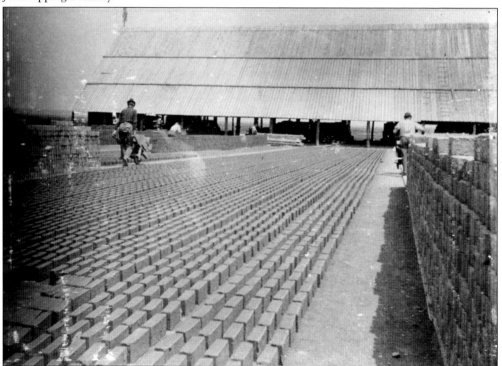

A portion of John Whitehead's brickyard, located at the bend in Reid Street, is visible in this photograph taken on May 24, 1895. While two workmen wheel bricks on handcarts, the common bricks dry in the sun. The brick industry was seasonal, from April to October. In the off-season, the workers took on other jobs to support their families.

In the early 1900s, the brickyard at the bend in Reid Street was sold and became the South River Brick Company. The barn on the property is shown here in February 1906, with the area around Maple, Henry, and William Streets in the background. The largest shareholder of the company was John Dailey, a retired boatman, who lived on Gordon Street.

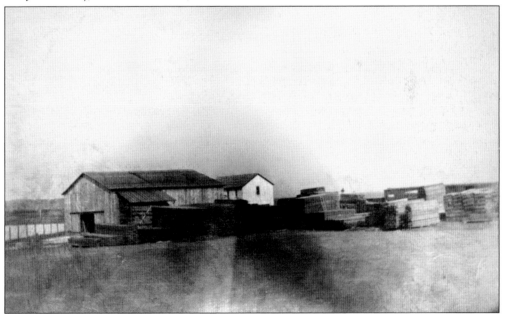

Harmon W. Cropsey and Lewis G. Mitchell, both of New York, were partners with Capt. John Dailey in the South River Brick Company. This February 1906 photograph is identified as Cropsey and Mitchell's lumberyard. The buildings were part of the Reid Street property belonging to the brick company. The lumberyard sold retail and wholesale building materials and related products.

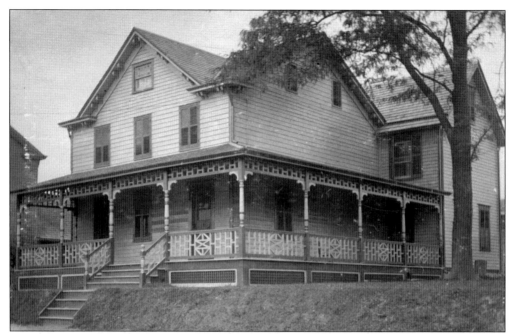

The residence of John Fee Jr., located on Reid Street across from Stephen Street, is pictured here on September 10, 1902. Fee was a successful wholesale liquor dealer, with a store on the corner of Ferry and Washington Streets. He became mayor of South River in 1913, when Joseph Mark resigned to become postmaster. Fee was reelected in 1915 and served until his death in 1917.

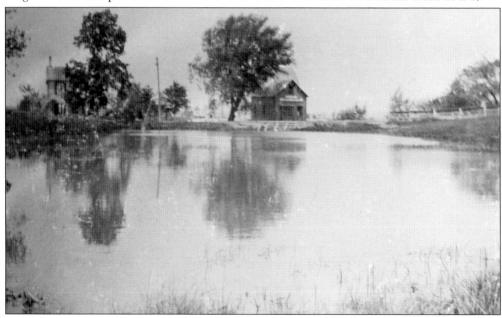

This photograph of Abraham Barkelew's ice pond, now Dailey's Pond, was taken on May 23, 1895. When the pond was frozen, ice was cut out in large blocks and used for refrigeration. Barkelew was a farmer and a large landowner in the borough. During the Revolutionary War, he was among those who submitted a claim for repayment of damages suffered when Colonial forces commandeered supplies.

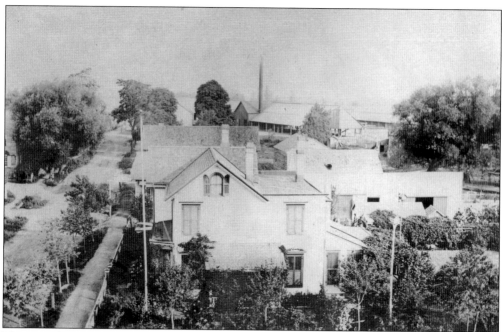

This view from the roof of the American Hotel looking north along Reid Street provides an aerial perspective on the neighborhood. Taken on August 3, 1896, the Peterson house is prominent, with a small portion of Gustav Wall's harness shop just visible beyond it. The smokestack and adjacent buildings are part of Whitehead's brickyard, where the Veterans of Foreign Wars Post No. 1451 was later built.

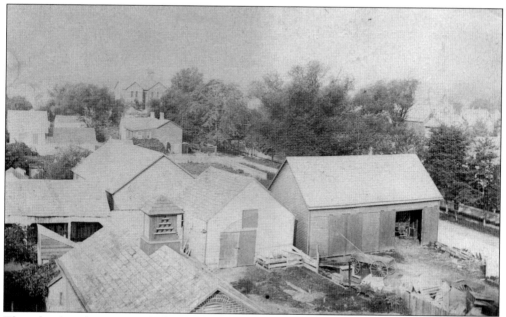

The school at the corner of Thomas and George Streets is just visible in the distance in this August 3, 1896, westward view from the roof of the American Hotel. The buildings in the forefront are part of the stable yard in the area behind Main Street's East Brunswick Hotel. The tree-lined thoroughfare is George Street.

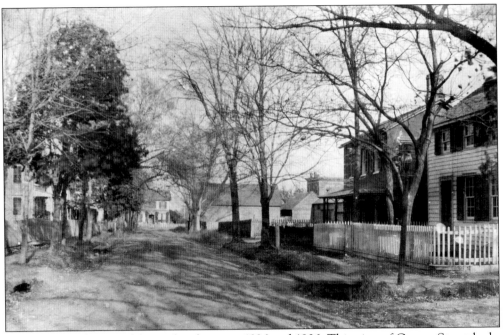

This undated photograph was taken between 1896 and 1906. This view of George Street looks east toward the river from the intersection with Stephen Street. The top of the American Hotel on Reid Street is just visible beyond the houses on the right. William H. Peterson's house can be seen on Reid Street directly across from George Street.

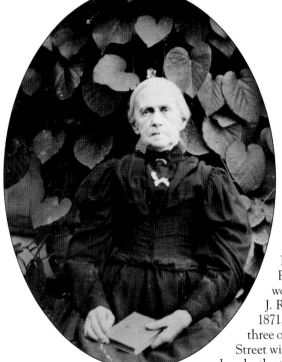

Her March 1901 obituary describes Mary A. Rhoads as "one of the best and most lovable women who ever lived." The wife of Rev. Levi J. Rhoads, a Methodist minister who died in 1871, she was the mother of five children, only three of whom outlived her. She resided on George Street with her daughter Eliza Adaline Rhoads until her death at age 90.

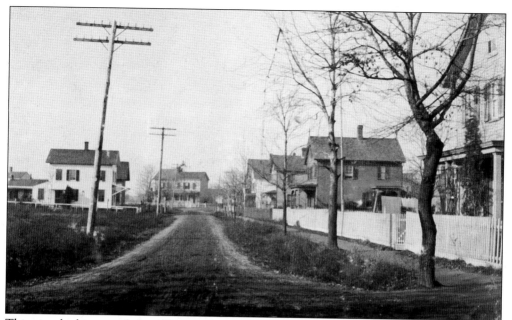

This view looking north from George Street to Reid Street shows Stephen Street on November 19, 1895. The last house on the left was owned by James D. and Emma Van Zandt, and other residents of Stephen Street included members of the Bergen, Coopey, Fritsch, Marks, Morgan, Rose, Serviss, and Van Deventer families. The building in the distance is the home of William D. Serviss, on Reid Street.

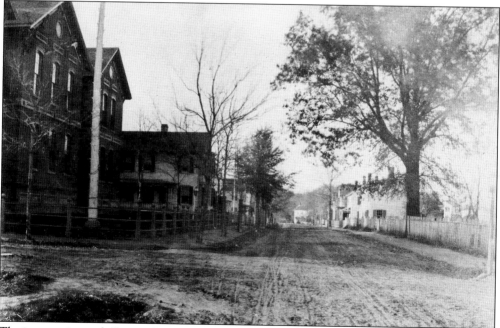

The intersection with George Street is the foreground in this photograph of Thomas Street looking north toward the junction with Prospect and Reid Streets. Pictured here on November 13, 1898, the public school, with its large flagpole, is prominent at the left. Beyond it is the residence of Elwood Manahan.

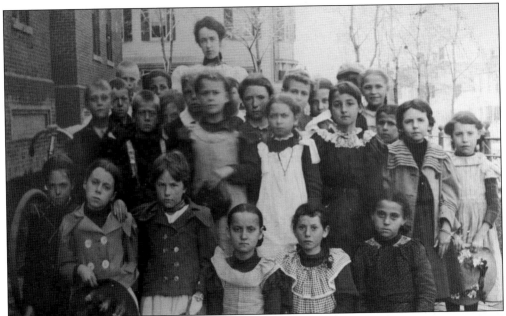

These two class photographs were taken in front of the public school on Thomas Street on April 19, 1899. Although the students are unidentified, the teacher in the back row of the image above is identified as Mae C. Morgan. Morgan married in April 1903, and had she not moved to California, she would still have had to give up her position. During this period, all female teachers were required to be unmarried. In the image below, Jesse Selover stands at the rear of his class. On May 24, 1899, a little more than a month after the photographs were taken, the school celebrated Public School Day in Washington Park, near the corner of Main and DeVoe Streets, with recitations, class exercises, and songs.

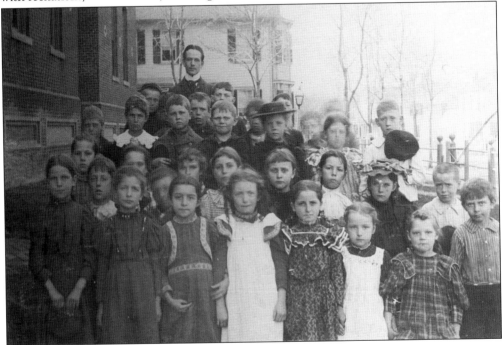

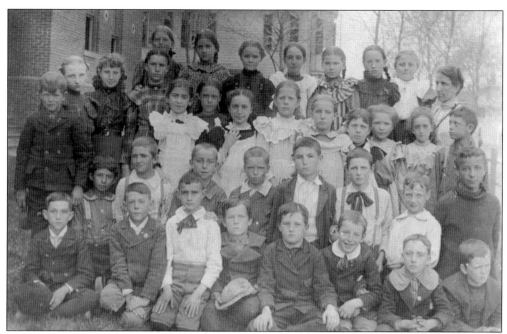

The teachers in these two class photographs taken on April 20, 1899, are identified only by their surnames. In profile at the right of the above photograph is Miss Bogan. Miss Van Arsdale is prominent at the rear of the group below. The residence of Elwood Manahan, located next to the school, is visible in the background of both photographs. Thomas Street, along with some of the houses opposite, can be seen at the right in the image below. The *Daily Times*, published in New Brunswick, reported that Arbor Day exercises were held at the school on April 28 of the same year. The program ended with the entire school singing the Civil War song "Marching Through Georgia" while two "larger boys" planted two trees.

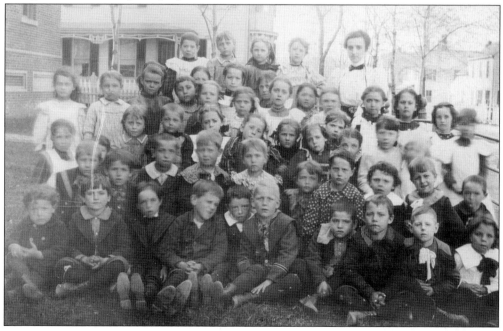

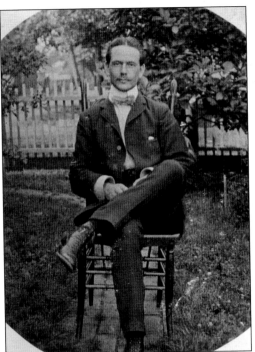

Jesse Selover was born in 1878 and died in 1958. He taught in the school on Thomas Street for a time before taking a position in Sayreville. Selover authored the unpublished "History of South River, New Jersey," which was eventually completed by his wife, Jean Armstrong. This photograph was taken in July 1901, the same month that the *Daily Times* of New Brunswick reported that he had his appendix removed.

This view from the rear of the school on Thomas Street shows the building before the two wings were added on the north and south sides of the original building. Taken on July 7, 1895, the photograph also shows a rear section that was approved for construction in 1890 and torn down when a larger addition was put on in the 1920s.

This undated photograph shows Wilbur C. Rose's grocery store on Thomas Street. The store, situated at the corner of George Street across from the school, opened in November 1905. Rose was mayor for a brief period at the end of 1917, following the death of Mayor John Fee Jr. He was elected again in 1919 to complete the term of Samuel Yates, who also died in office.

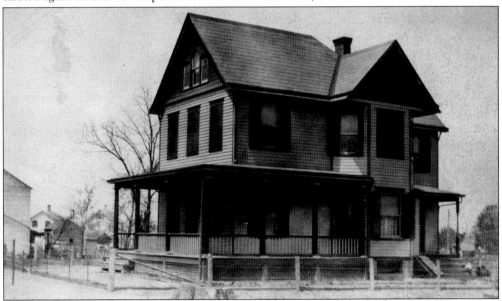

Located across from the school on Thomas Street, Michael and Amelia Jacquart's residence was built in 1903 and photographed soon after. When the house was first erected, there were many undeveloped lots in the area. Jacquart, a foreman at the tile works when the 1900 census was conducted, was a machinist by trade. He was also a Freemason.

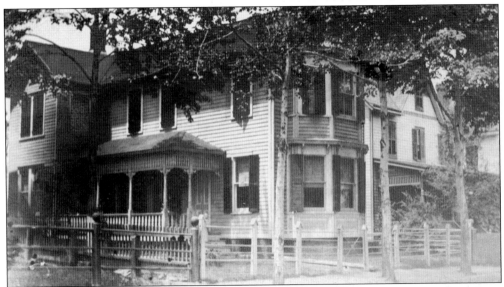

Elwood Manahan's home was located next to the school on Thomas Street. The photograph shows the house as it appeared in October 1904. Manahan owned a livery stable for many years and worked as a janitor in the public school after he retired. He was one of the first borough councilmen, served on the board of education, and was a member of the fire department.

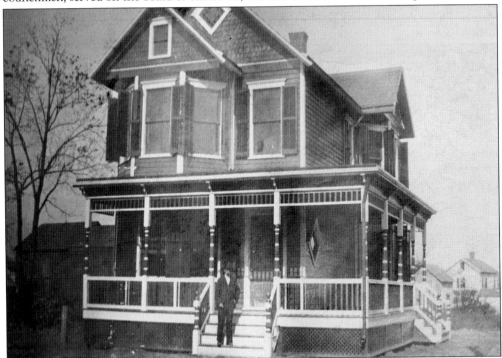

The Thomas Street residence of Silas Wright is shown here in October 1904. Having worked as a tavern keeper, a farmer, and later a carpenter, Wright died in January 1915 after a long illness. The property was left to his wife, Emma, for as long as she lived and remained unmarried. The secondary legatees were his children Edna McCardell, Margaret M. Lindberg, John B. Wright, and Douglas L. Wright.

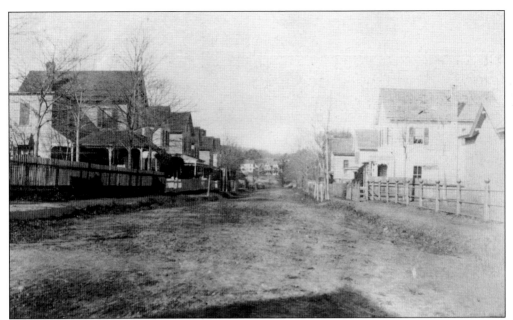

Leland Avenue, directly behind the school on Thomas Street, is pictured here on November 13, 1898. Already well developed at this time, the neighborhood included members of the Barkelew, Mark, Stone, Freehan, Hasse, Anderson, Hillyer, and Jernee families. The building at the right advertises a house painter and a jobbing shop, which would have manufactured small batches of made-to-order items.

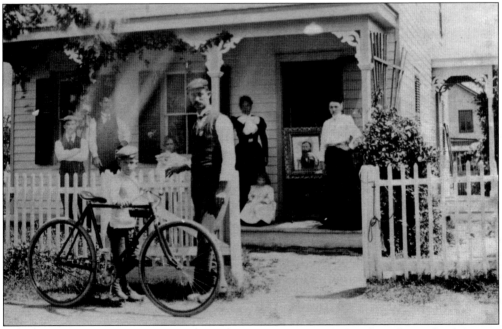

This June 1899 image shows the Charles W. Freehan family with friends at their Leland Avenue home. Freehan lived with his wife, Anna, and his three children, as well as his brother-in-law Charles Tewes and a nephew. Freehan had a barbershop on Main Street near the East Brunswick Hotel, and his son Charles also worked there for a time.

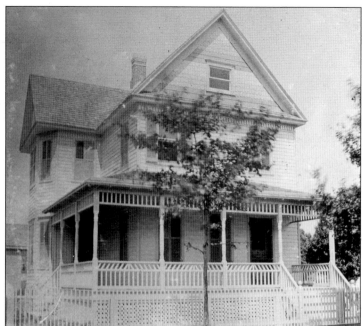

The George Street residence of Christopher Weiss, at the corner of Clinton Street, is shown here on August 22, 1899. Weiss was a bookkeeper at the American Enameled Brick and Tile Company. He lived here with his wife, Mary, and their three children before the family moved to New York in the early 1900s.

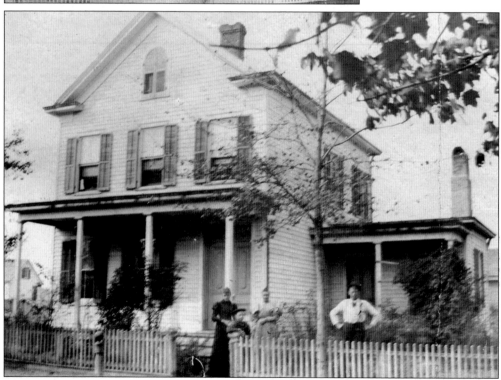

The home of Daniel C. Selover, pictured here on October 26, 1895, was next to the Weiss home on George Street. Selover, a boatman and carpenter, was, at various times, a member of the board of commissioners that governed South River before its incorporation in 1898. He and his wife, Lydia, had five surviving children when the 1900 census was conducted. Jesse Selover was the middle child.

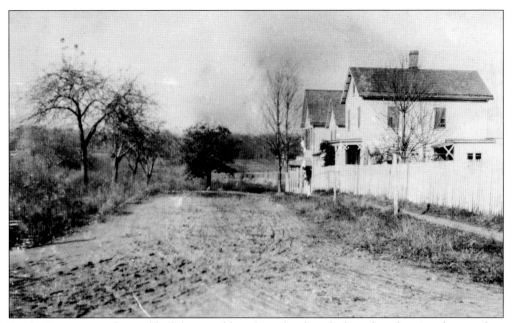

Bright Street was only one block long and largely undeveloped when this photograph was taken from George Street on November 21, 1898. Additional houses were built after 1910, and Ziegert Street, originally called Clay Street, marked the far end. Much of the property was owned by the South River Brick Company. Colonel Allen, one of the first African Americans to own a home in the borough, lived on this street.

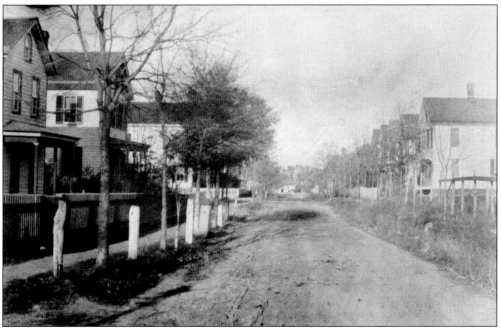

The subject of this November 13, 1898, image is a view of upper George Street looking east from Bright Street, toward the river. Less than 25 years before the photograph was taken, George Street only extended from Reid Street to Thomas Street. This neighborhood must have developed relatively quickly during the late 1800s.

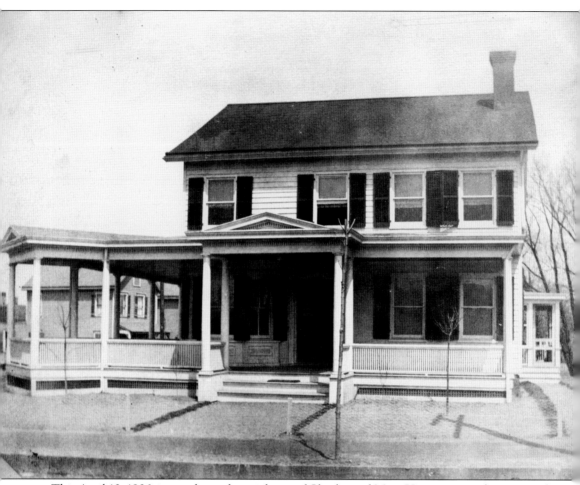

This April 13, 1906, image shows the residence of Charles and Mary Herrmann, at the corner of Thomas and George Streets, just months after its completion. The house was originally owned by Dr. John C. Thompson and located on Main Street at the Thomas Street corner. Herrmann modernized the house with electricity, steam heat, and other amenities. He also added a summer dining room and the wraparound porch seen in the photograph. Later in April 1906, builders laid the foundation for the new store Herrmann erected on the site where the house was originally located. He was a successful businessman, a supervisor at the Herrmann, Aukam, and Company factory, and postmaster for a time. Herrmann and his wife both died in 1945. The house was eventually torn down, and the property became a parking area for the South River Fire Department.

Two

TOWN CENTER

Andrew S. Church's feed and grain store, located at the foot of Main Street, is pictured here on April 13, 1906. The building was later occupied by the Laffin car dealership for nearly 80 years. The Hoffman House, a hotel and saloon, sat next to the store until the hotel burned in the 1920s and was replaced by the Pershing Hotel in 1930.

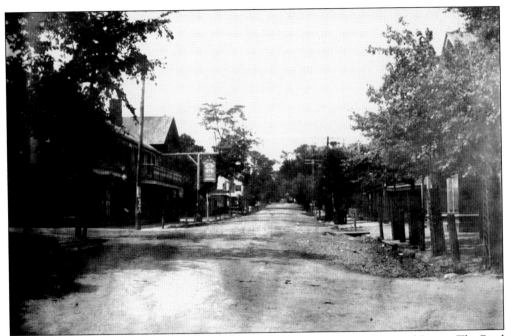

The view in this July 12, 1895, image shows Main Street looking west from Reid Street. The Reid Street corner is just visible at the right, and Ferry Street can be seen at the left. Beyond Ferry Street are a dry goods store, the Washington Hotel, and Citizen's Hall. Across Main Street are Jacob Levinson's dry goods and clothing store and the East Brunswick Hotel.

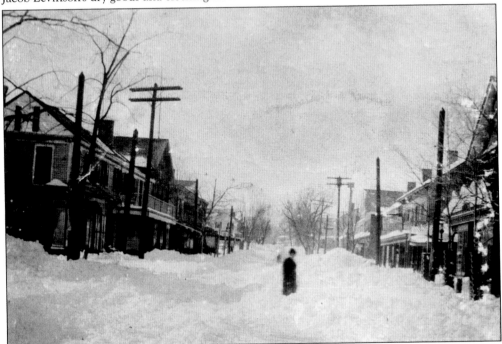

Richard Van Dyke Reid captured this view, similar to the one in the previous image, while standing near Ferry Street on February 15, 1899. It was the worst snowstorm to hit the area since the blizzard of 1888. Drifts of three to four feet caused schools and factories to close for three days.

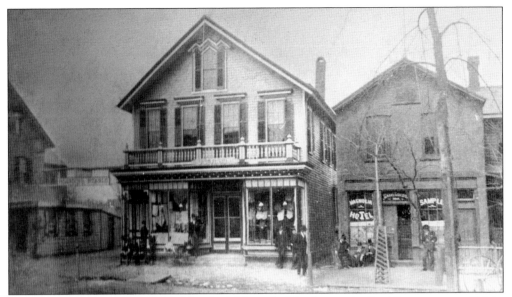

Jacob Levinson's store and Samuel Gordon's Magnolia Hotel, near the Reid Street corner of Main Street, were photographed on May 25, 1892. The first tavern in South River, run by a member of the Obert family in the 1700s and early 1800s, is thought to have been located here. In 1825, Samuel Gordon Jr. built the first brick house in the village of Washington in place of the tavern.

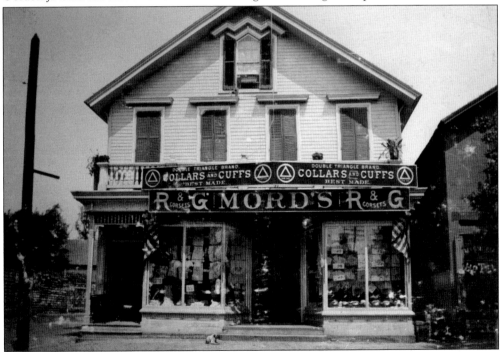

On June 29, 1900, Jacob Levinson's Main Street store advertised corsets, collars, and cuffs. Levinson was a key businessman, financier, and civic leader in the early 1900s. He provided check cashing, loans, and other financial services. The building later became Robin's Department Store, with the South River Trust Company building to its left. It was torn down in the latter half of the 20th century.

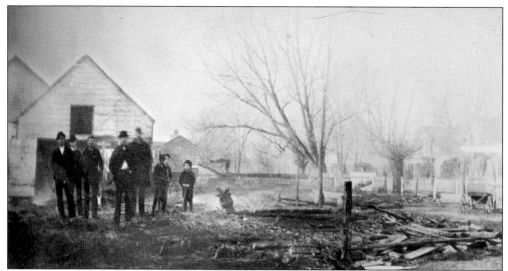

The damage caused by the November 22, 1894, fire on the Jacob Levinson and Benjamin B. Walker properties is evident in this image. Levinson's store and Walker's East Brunswick Hotel were side by side on Main Street. The fire was restricted to the barns and other outbuildings located behind the businesses and stretching to George Street. A bucket brigade made up largely of women and children is credited with extinguishing the fire.

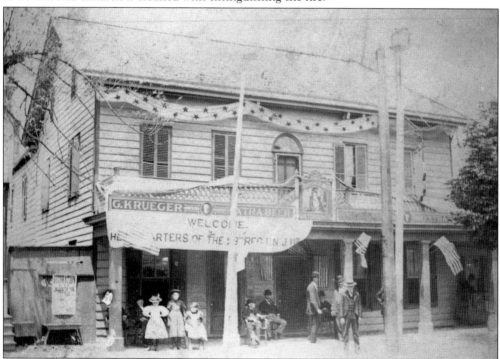

Memorial Day, May 30, 1896, was the occasion for this photograph of the East Brunswick Hotel. Benjamin B. Walker owned it from the 1870s until about 1900. He also provided the venue for the first election and first meeting of the town commissioners in 1870. In 1936, the last owner of the hotel, Jacob Rutkowski, shot and killed Police Chief Eberwein in the police station over a liquor license violation.

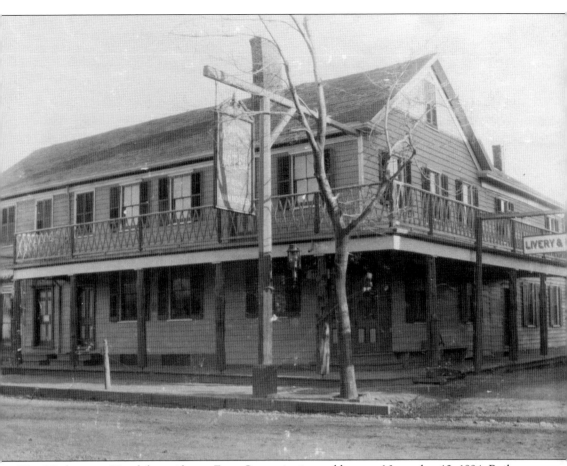

The Washington Hotel, located near Ferry Street, is pictured here on November 12, 1894. Built in the 1820s by Abraham Barkelew and Joseph Gulik, it became a mecca for steamship tourists who appreciated the vantage point of the wraparound porches. The hotel included a tavern and, at various points in its lifetime, a cardroom, bowling alley, and shuffleboard court. Elwood Manahan's Livery and Boarding Stable was located behind the hotel, as evidenced by the sign at the right edge of the photograph. The building sustained damage to the wine room and the bowling alley when the so-called Schroeder fire occurred in July 1908. During Prohibition, the hotel was a key bootlegging establishment under proprietor Otto Lindberg. It was torn down in 1956, and the site later became the home of Z and Z Building Supply.

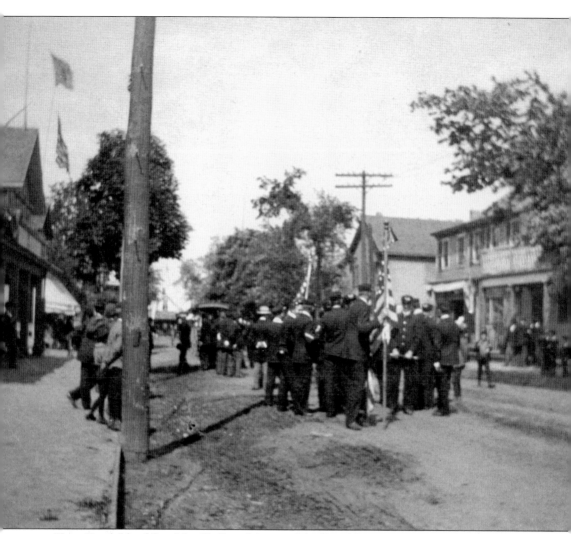

Here, Frank Lloyd Post No. 67, Grand Army of the Republic, congregates on lower Main Street in front of the East Brunswick Hotel for the May 30, 1899, Memorial Day parade to Washington Monumental Cemetery. The members of the organization were Civil War veterans from South River and surrounding areas who participated on foot and in horse-drawn wagons. Their wives formed a sister organization known as the Women's Relief Corps. Following the service at the cemetery, refreshments were provided at the American Hotel on Reid Street, where the organization was based. Felix Letts, a former South River resident employed as a congressional page in the office of the doorkeeper in the US House of Representatives, gave an address. The GAR plot at the cemetery is marked by a flagpole and nine gravestones bearing the names John Bell, Mary A. Bell, Frederick Decker, Henry L. Deuel, Martha A. Deuel, William H. French, August Habaghan, William Haines, William McCord, and William H. Smith.

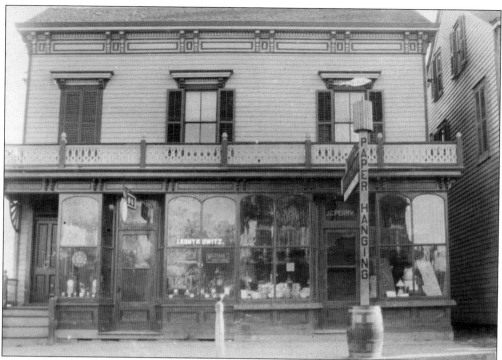

The Perry Building is shown here on November 12, 1894, and again on June 11, 1900. In the earlier photograph, Joel C. Perry's variety store shares the building with the watch and clock shop of Isadore Kontrowitz. Perry's signs and display windows advertise such diverse items as painters' supplies, paper hanging, fishing tackle, and household goods. By 1900, George Radcliffe had replaced Kontrowitz in the left side of the building. Radcliffe sold groceries and cigars and provided a rest stop for cyclers. The building was destroyed in the 1908 fire, two years after it was sold to Peter Knapp. A new building was erected soon after the fire and has since been home to a variety of businesses. It was the first location where beer was sold in South River after the repeal of Prohibition.

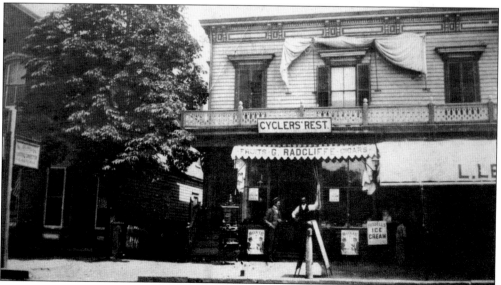

On April 19, 1894, when this photograph was taken, the Schroeder Building housed the post office and Henry Schroeder's Hairdressing Parlor. It was the starting point for the July 10, 1908, fire that decimated the heart of the downtown area, destroying much of the section between Obert and Ferry Streets. The post office relocated before the fire, and the new location in Citizen's Hall was among those that burned.

The residence of James Bissett, the first mayor of South River, is shown here on June 27, 1898. Located next to the Schroeder Building, it was among the structures destroyed during the 1908 fire. Bissett had a successful brick business near present-day Bissett's Pond and a dock for shipping bricks on barges and schooners to New York and other areas in New Jersey via the South River.

Pictured here on May 22, 1900, is the bargain store run by Abraham Feible and his family. It was located on Main Street, across from Stephen Street, in a building owned by John Whitehead. In June 1901, little more than a year after the first photograph was taken, the structure was destroyed by fire. The family, who also lived in the building, jumped to safety from the back porch when the fire was discovered. The trolley wires in front of the store were damaged, and William Norman's butcher shop, Citizen's Hall, and former mayor Bissett's house were threatened. Bucket brigades and chemicals were used to put out the flames and keep them from spreading. The value of the building was estimated at $4,000.

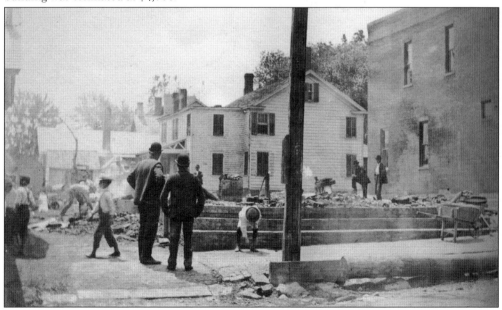

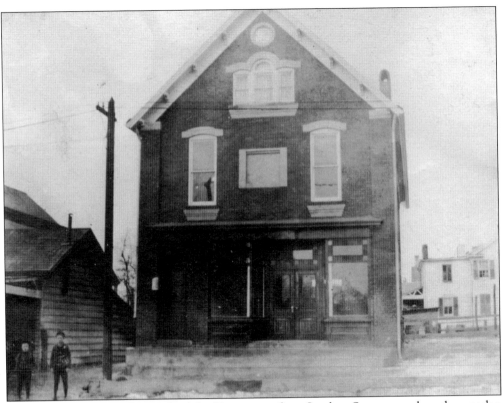

John Whitehead erected a new brick building across from Stephen Street to replace the wooden structure that burned on June 12, 1901. The medallion at the peak of the roof dates the new building to 1902. It survived the Main Street fire of 1908 without notable damage. Hansen's Danish Bakery, Clementis Restaurant, and River Thai Cuisine are among the businesses that have found a home there over the years.

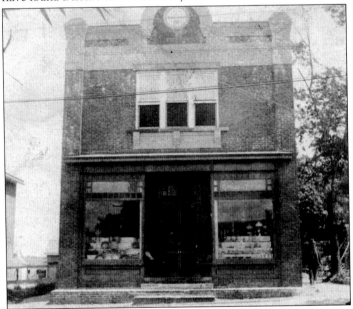

This building on the corner of Main and Obert Streets was erected by John Whitehead in 1901 and photographed in July of that year. Like many buildings on Main Street, it has been home to a variety of businesses, including James T. Black's grocery store, a nickelodeon theater, the Armstrong Sales Corporation automobile dealership, and Duschock's Pharmacy. The room upstairs was used for WPA sewing projects during the Great Depression.

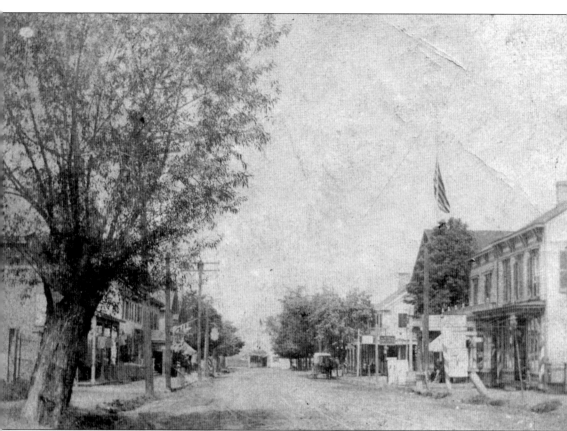

A view of Main Street looking east from the Manahan property is the subject of this photograph taken on May 30, 1898. At the end of the street, near the river, the Riverside House saloon is visible. The Washington Hotel and the East Brunswick Hotel sit opposite one another, and stores and other businesses round out the neighborhood to make it one of the key shopping areas in the borough. The house once owned by James and Elizabeth Manahan was moved in December 1907, when ground was broken for the erection of the borough hall, which opened in August 1908. Among the items placed in the cornerstone of the new building was a roster of borough officials, a note identifying Manahan family members born on the property, a photograph from the family of Mayor Joseph Mark, coins, and paper money. Business cards from Casimir Offenburger Jr., J. M. Barkelew and Company, Alexander Merchant and William H. Boylan, and William H. Van Sickle Jr. were also included. In the 21st century, the structure was renovated. It reopened as the Criminal Justice Building in 2003.

Having received his degree in 1856, Dr. John C. Thompson established a practice in South River, which he maintained until his death in 1894. Married twice, he lived on Main Street at the corner of Thomas Street. A March 1889 news item identifies Thompson as a member of the East Brunswick Board of Health. The South River equivalent was established in April of the same year.

In 1906, Charles Herrmann built his store on the site of Dr. John C. Thompson's former residence at the corner of Main and Thomas Streets. He relocated the house a short distance away on the corner of Thomas and George Streets. The second floor of his general store included a furniture department, which in later years was replaced with an underwear factory run by Charles and his brother Samuel.

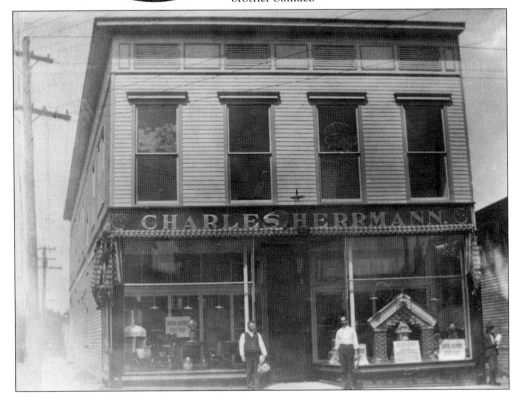

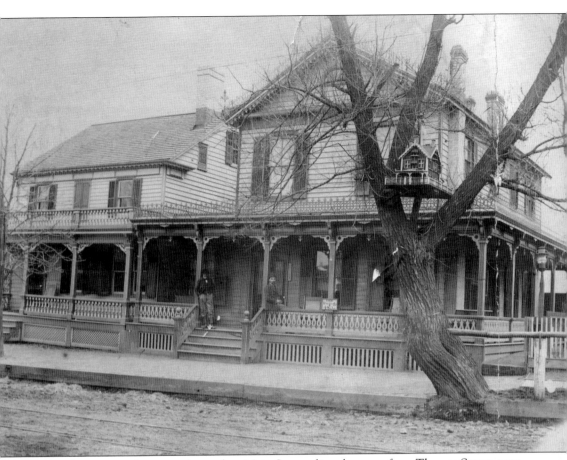

The two houses seen here were located on Main Street, directly across from Thomas Street, next to the Old School Baptist Church. The home on the right was originally a single-story structure, erected in 1838 to replace the schoolhouse located near DeVoe Street. It was enlarged to include a second floor in 1852. The building was sold and converted into a private residence after the school on Thomas Street opened in 1885. In the late 1890s, when the photograph was taken, the house was among the property owned by Charles S. Smith, a well-to-do resident who also owned property in New York. He was married to Belle Stults Culver, the daughter of Alfred Stults. Smith died in 1899, his wife in 1902. The house changed hands and was finally purchased by Anthony J. Alexander and his brother John Alexander in the early 1930s. It was torn down in 1932.

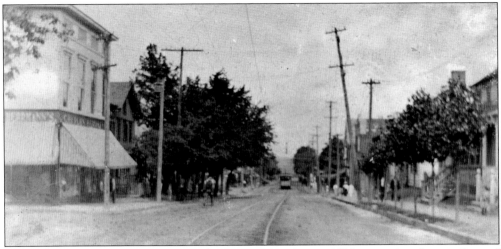

The downtown area of Main Street is the focus of this August 1906 view taken from in front of what was, at that time, the Old School Baptist Church. At the left, the striped awnings of Charles Herrmann's store mark the corner of Main and Thomas Streets. In the distance, the trolley can be seen as it approaches the turn onto Ferry Street. The river is visible beyond the trolley.

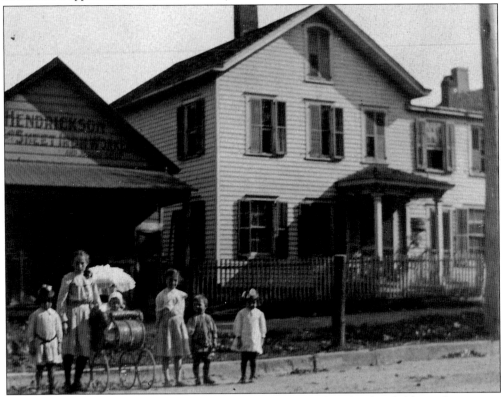

Ross Hendrickson's Tin and Sheet Iron Works form a backdrop for the children who pose in front of the business in August 1906. The shop was located two buildings beyond the Old School Baptist Church in the direction of Gordon Street. Edith Van Deventer, about 12 years old at the time, is the only one of the children identified by name. The house next door has survived into the 21st century.

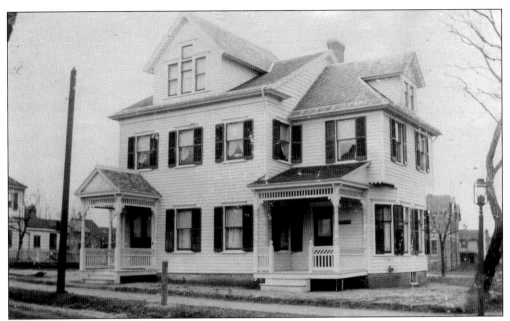

William H. Thoburn married Elizabeth "Libby" Rush of Sayreville on February 13, 1879. Although there were times when they lived in the stately Thoburn Building at the corner of Main and Thomas Streets, it was also a rental property. Photographed on December 15, 1897, it was moved in the 1920s, and a commercial building was erected in its place. The location is best known as the home of Boyt's Pharmacy.

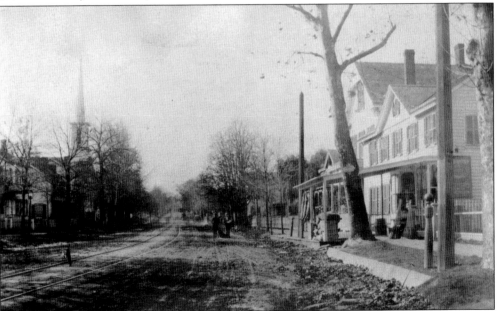

Although not shown in the photograph, the residence of the Abraham C. Price family was the anchor point for this November 13, 1898, image with a view of Main Street looking west. The Price home was located between the Thoburn Building and the grocery store that occupied a portion of the structure visible at the right. Farther along the street, the Methodist Episcopal church is also visible.

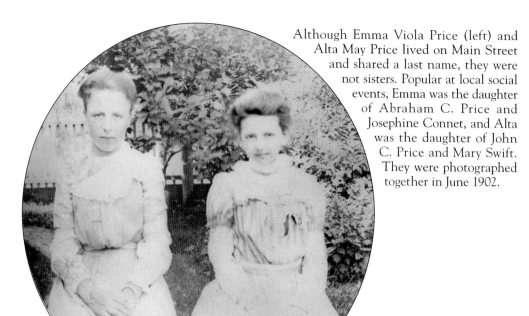

Although Emma Viola Price (left) and Alta May Price lived on Main Street and shared a last name, they were not sisters. Popular at local social events, Emma was the daughter of Abraham C. Price and Josephine Connet, and Alta was the daughter of John C. Price and Mary Swift. They were photographed together in June 1902.

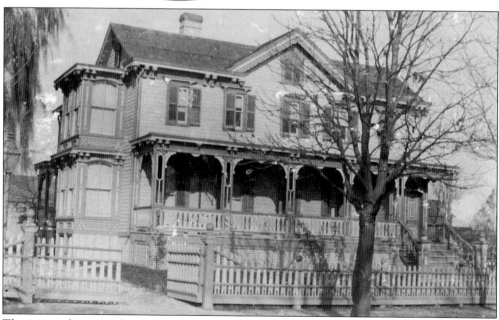

This ornate house is the residence of Henry Herrmann as seen on November 12, 1894. The property spanned several lots and extended back to George Street. It included a private driveway, barns, and a lawn tennis court. Herrmann, a supervisor for Herrmann, Aukam, and Company, decorated the house with "cut flowers, potted plants and ferns" so his daughter's 1910 wedding would look like "a veritable picture of spring."

Three

GATEWAY TO THE RIVER

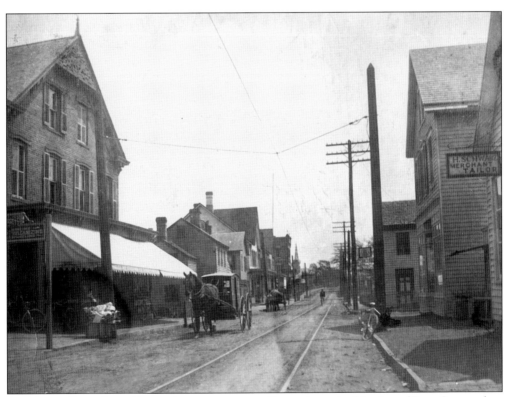

Bicycles, trolley rails, and horse-drawn wagons are all prominent in this view of Ferry Street taken on May 5, 1900. John Whiteman's store is at the left, with a sign for Frederick William Bissett's business in the forefront. Henry Schwarz's tailor shop is on the right. In the distance, the steeple of the Episcopal church at the corner of Whitehead Avenue and Martin Avenue is just visible.

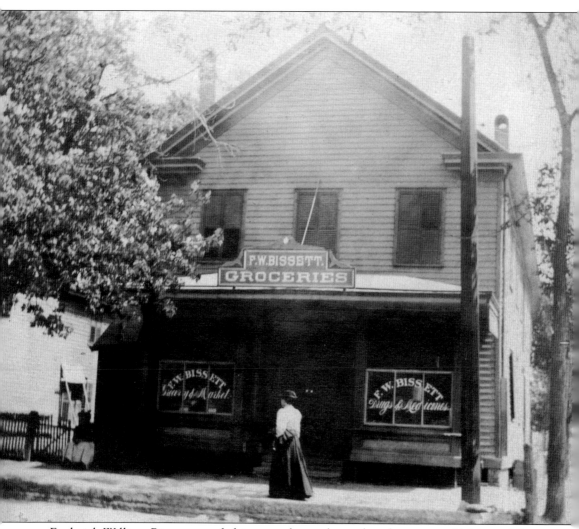

Frederick William Bissett owned this general store located at the corner of Main and Ferry Streets. Photographed in the 1890s, the windows advertise it as a grocery and market as well as a source for drugs and medicine. By 1900, it also provided essential items such as wood, ice, hardware, windows, and paints. Although the 1870 census identifies Bissett as a grocer, by 1880 he had added the profession of physician to the public record. The small drug department in the store was one of the first pharmacies in the borough. Born in 1843, Bissett was a naval surgeon in the Civil War and served in several engagements. He was president of the South River Board of Health at the time of his death in 1906. A decade later, the Grand Hotel was built on the site the store formerly occupied. The hotel was subsequently turned into apartments.

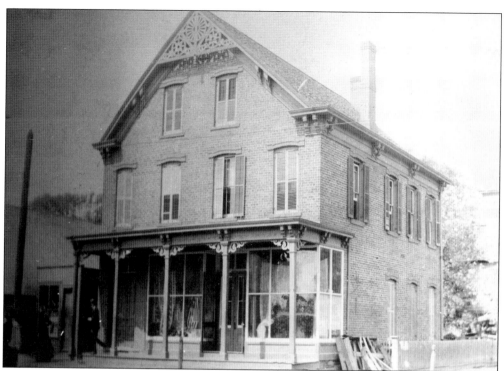

John Whiteman's dry goods store was established in 1897 at the corner of Ferry and Washington Streets. The block of Washington Street that ran next to the building later became Eberwein Street. The store sold everything usually found in a first-class department store, including staple and fancy goods, men's clothes, ladies' ready-to-wear garments, girls' and boys' clothing, notions, millinery, shoes and rubbers, oilcloth, linoleum, carpets, and even bicycles. On November 2, 1901, the show window featured a display of fashionable ladies' hats for the season. In 1913, Whiteman built a larger store on Ferry Street, the largest in the borough at that time. He and his family made their home on the top floor.

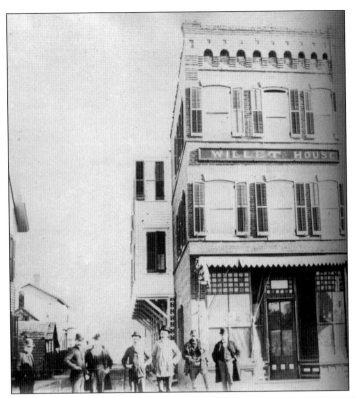

The Willet House hotel and saloon, at the corner of Ferry Street and Klausers Lane, was built in the 1890s by Theodore S. Willett Jr. and photographed on July 26, 1897. The spelling of the Willett name varied. After Theodore's death at age 28, his brother Charles managed the business with the help of their mother, Sarah Jane Willett. Later called Farley's Tavern, it was destroyed by fire in 1983.

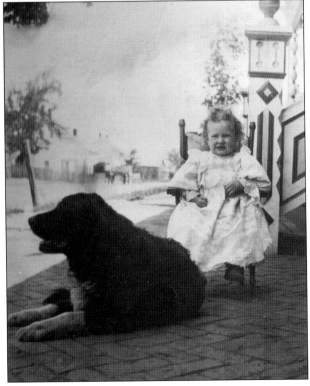

Thera May Willett, pictured here on June 7, 1898, at age two, was the daughter of Theodore S. Willett Jr. and Mary A. Daly. Theodore was the proprietor of the Willet House on Ferry Street until his death in 1899. Although challenged in court by her father-in-law, Mary administered her husband's estate and retained custody of Thera. Thera's sister Miriam was born six months after her father's death.

The view along Ferry Street looking from Jackson Street toward Main Street was a much different landscape when this photograph was taken on July 10, 1895. The house on the left with the laundry hanging on the clothesline is at the corner of Washington and Ferry Streets. It was later replaced by the Klauser Building. The store on the right is Conrad Mark's watch and jewelry shop.

The Klauser Building is shown here on January 20, 1899, shortly after being constructed by Ambrose Klauser. In early years, the top floor was known for the social functions that were held there, including the annual Martha Washington Society masquerade ball. Located at the corner of Ferry and Washington Streets, it was home to businesses for many years but became a rooming house before being destroyed by fire in 1979.

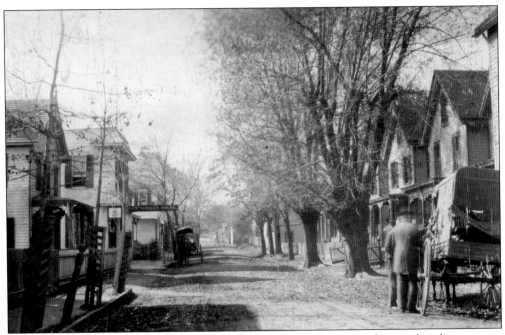

This view of Washington Street, taken near Ferry Street, captures the tree-lined avenue on November 4, 1898. The Van Norden House hotel, with the horse and buggy in front, is prominent on the left. Although not visible, the National Hotel was just a few doors beyond the Van Norden House.

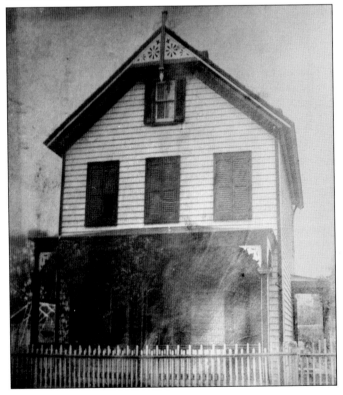

The William L. Roller house on Washington Street, seen here on October 12, 1896, was located between the Klauser Building and the Van Norden House hotel. Roller was a brickmason who lived in the house with his wife, Emeline, and their two children, Kathryne Mae and Albert William. His father, Capt. William Roller, is identified in the 1860 census as the master of a sloop.

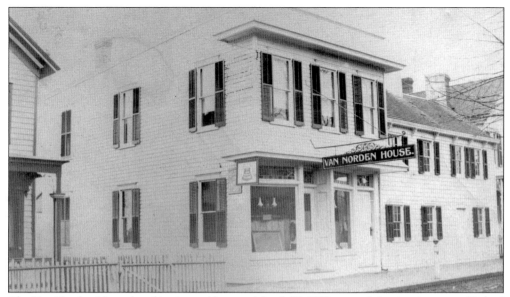

The Van Norden House hotel is pictured here on March 18, 1897, around the time it was established by John Van Norden at 8–10 Washington Street. It was sold to Frederick H. Quad in 1905 and subsequently referred to as both Quad's Hotel and the Van Norden House. Quad sponsored annual feasts of ducks and turkeys gathered during hunting trips with William Goggin. The hotel later became a private residence.

This photograph of the residence of William H. Serviss at 12 Washington Street was taken in March 1897. Serviss was the owner and captain of a schooner for many years and worked as the janitor at School No. 2, later renamed Willett School, before his death in 1914. Born in 1848, he married Louisa Knapp, and together they had seven children.

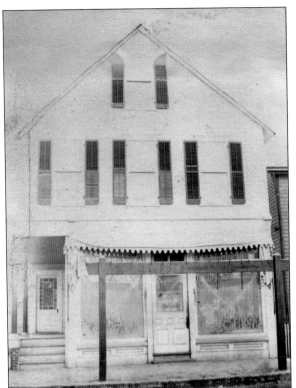

Herman Eulner lived in Newark in the 1880s, but he had settled in South River by the early 1890s. The structure owned by Eulner, pictured here on January 20, 1899, was located at 14 Washington Street. He and his son Herman Jr. ran a butcher shop in the building. It was also the family residence. After the repeal of Prohibition in 1933, the building was converted into a bar.

Obert Street was named in honor of Peter Obert, an early settler and one of the original trustees of South River's Old School Baptist Church. Small businesses, such as the "fancy bakery" at the left, were interspersed among the houses in this November 8, 1898, view looking south from Main Street.

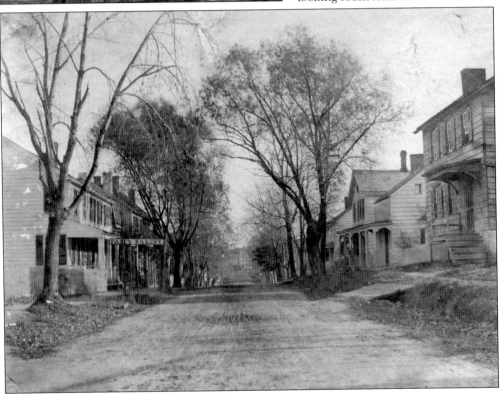

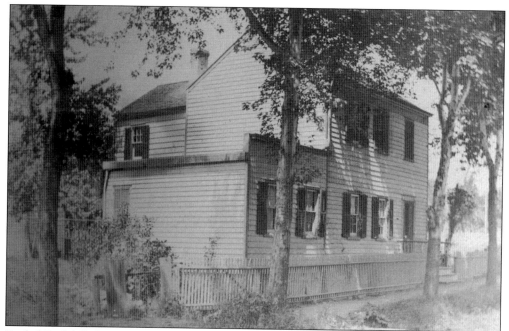

Rachel Radcliffe lived in this house on Obert Street until her death at age 81 in August 1904. The widow of John Radcliffe, she was survived by three sons and a daughter, who were involved in a dispute over the property after her death. Her husband, John, was a stage driver when he contracted typhoid fever and died in 1887. The house was photographed on July 5, 1905.

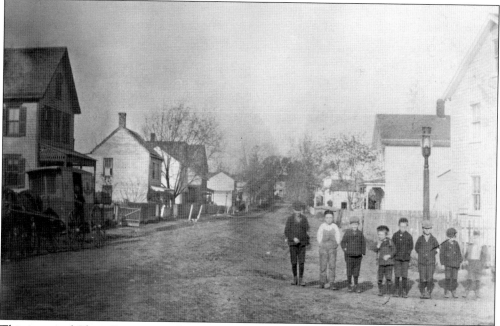

This image of Obert Street was taken from Jackson Street on November 13, 1898. The boys in the group were likely thrilled to have their photographs taken. The horse and wagon at the left bears the name of a business—too faint to read, but almost certainly belonging to one of the small operations in town.

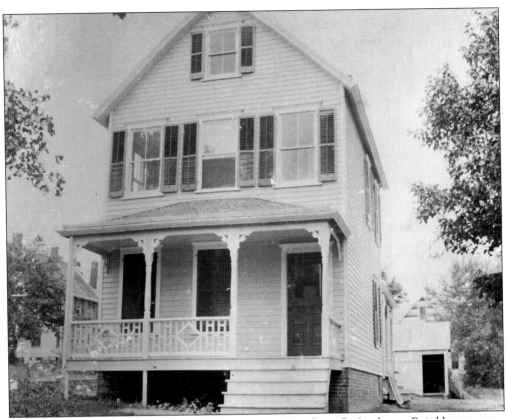

The Cora G. Applegate Baird house, on Washington Street, was photographed on July 29, 1897. Her husband, John Baird, the former owner of the Swan Hotel, died the same year at age 38. In early 1906, Cora Baird and Mildred De Hart, her boarder, opened a dressmaking business in the Baird home to the delight of borough residents, who had long felt the need for such an establishment.

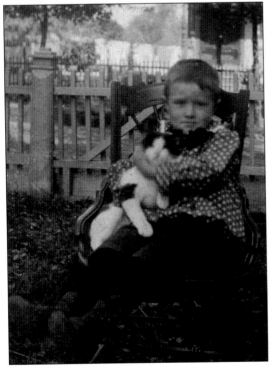

Born in 1893, Phillip Patterson is pictured here in the late 1890s with his cat. The 1900 census lists him as the youngest of eight surviving siblings in the home that his family rented on Gordon Street. His father was an Irish-born day laborer. By the time of the 1910 census, the family had moved to Milltown.

Pictured here on June 7, 1898, is the blacksmith and wheelwright shop of John Conover Bowne at the corner of Gordon and Washington Streets. The building was razed in the 1920s, and the lot has been vacant since that time. Bowne's daughter Julia was the subject of scandal when she ran away with the married pastor of the Methodist church, Rev. J. Frank Cordova, in 1904.

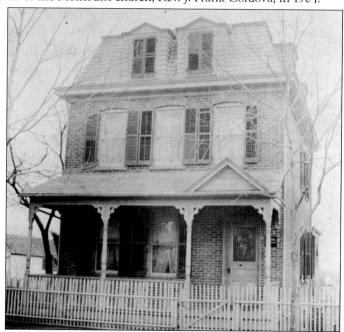

Shown in March 1902, this former residence of John Hohl was located at 70 Washington Street, near the Union Baptist Church, then the German Presbyterian Church. Hohl, his wife, Annie, and their children were among the families that emigrated from Switzerland in the late 1800s to take up residence in South River and work in the local embroidery industry.

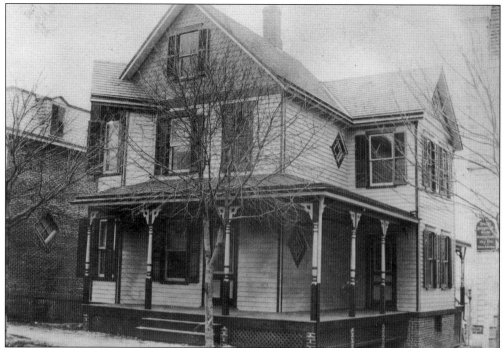

Built in 1901, the parsonage of the German Presbyterian Church, located on Washington Street next to the church, was photographed on December 23 of that year. The Reverend William J. Kern was pastor when it was erected. The sign just visible at the right edge of the photograph is on the church. It identifies the building as Die Deutsche Presbyterische Kirche.

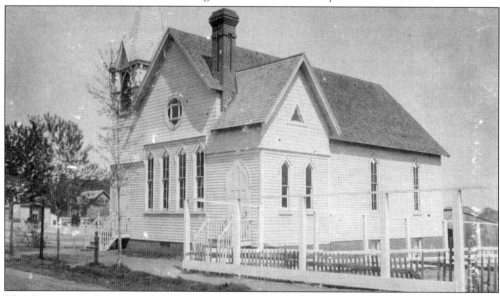

The German Presbyterian Church was built on Washington Street in 1894 on property donated by Gustav Wall. Previously, residents walked to Sayreville for services. After World War II, it was renamed the First Presbyterian Church of South River and later Trinity Presbyterian Church. The building was sold to the Union Baptist Church in 1963, and Trinity Presbyterian Church moved to East Brunswick. The photograph was taken on May 7, 1900.

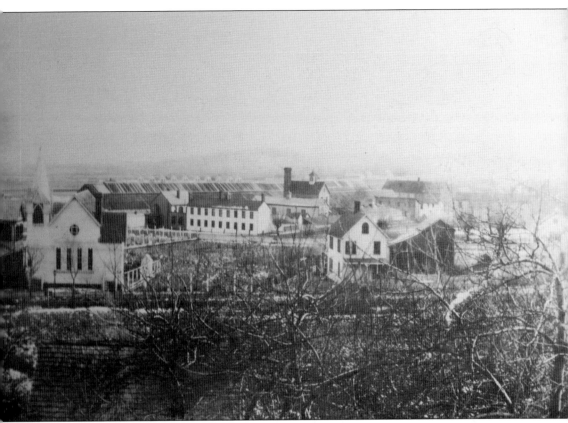

The top of Nathan W. Clayton's home on Main Street was the platform for this January 18, 1902, view looking southward. The German Presbyterian Church, on Washington Street, is visible in the foreground at the left. A portion of the parsonage next door can also be seen at the edge of the photograph. The long white building in the center of the image is a boardinghouse on Jackson Street, for the workers at Theodore Willett's brickyard. The smaller buildings that surround the boardinghouse include a bake house, a chicken house, an icehouse, a repair shop, and a blacksmith shop, all on the Willett property. The roofs of a long row of kiln sheds that extend into the Yates Brothers brickyard, adjacent to Willett's, span almost the entire width of the photograph and form an artificial horizon line.

The view shown in this photograph is captioned "Jackson Street, west from cemetery gate, November 12, 1898." In the late 19th and early 20th centuries, Raritan Avenue was known as Cemetery Road. It provided an entrance to Washington Monumental Cemetery from Jackson Street. Taken from a point near the bend in Jackson Street, the image gives a panoramic view stretching up toward Main Street from the cemetery gate at the left edge to the houses on Washington Street at the right. The large group of buildings on the left, beyond the cemetery gate, is part of the complex at Willett's brickyard. The three nearest buildings on the right are on Washington Street. The smaller house and the small building with the long sloped roof are also visible in the view from the top of N.W. Clayton's house seen on the previous page. In the distance, two houses on Main Street can be seen, one at the corner of Main and Virginia Streets and the other closer to the downtown area.

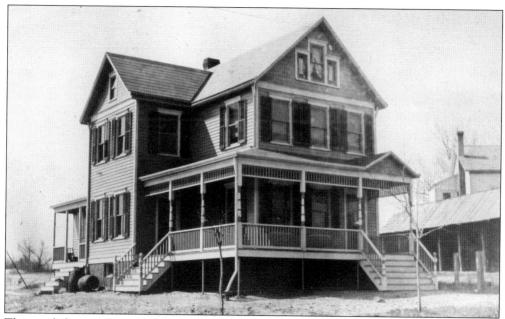

The stately home of Ross Hendrickson was located near the top of Jackson Street. Hendrickson was a tinsmith, sheet-iron worker, and plumber with a business on Main Street near Obert Street. In 1910, he was single but rented rooms to four female boarders, the Holton sisters. He married the eldest sister, Lillie, and the couple lived in the house until 1927, when Hendrickson died. His wife died in 1935.

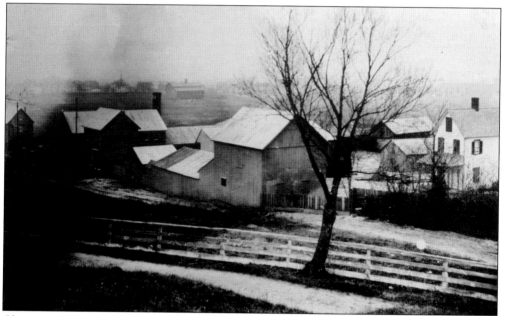

Clayton and Pierson's lumberyard, later Clayton Lumber, was founded by Nathan Willard Clayton and Elbert C. Pierson. It was located on Willett Avenue near the railroad tracks. Although they had customers all over the country, it is said that most of the houses and other buildings erected in South River from about 1894 until the 1950s were built with their lumber. This undated view was taken from the cemetery.

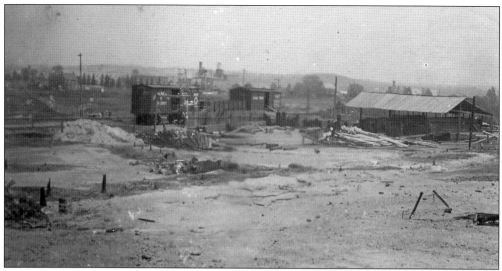

Pictured here are the remains of Clayton and Pierson's lumberyard on May 25, 1897, after an overnight fire sparked by lightning destroyed most of the complex. Three buildings and all but one small shed burned, along with a railroad car full of lumber. The damage was estimated to be at least $15,000. The business was soon rebuilt and prospered until 1938, when it was again struck by fire. The *New York Times* reported that 1,000,000 board feet of lumber was destroyed, and concrete and lime stocks were damaged. The business was owned solely by Clayton by that time, and losses were estimated at between $150,000 and $200,000. Clayton again rebuilt. In spite of his death in 1949, the business continued to prosper until 1970, when a final fire destroyed it. A large apartment complex and other homes were subsequently built on the property.

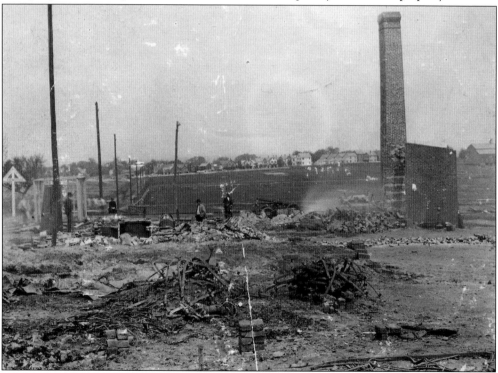

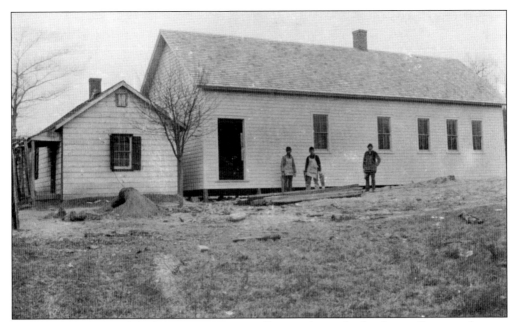

The emergency hospital, built in response to a smallpox epidemic that hit Sayreville, is seen here on December 23, 1901, shortly before its completion. Located near Clayton and Pierson's lumberyard, it had separate wards for men and women and included a morgue as well as housing for nurses. The first patient admitted was Dr. Charles B. Burnett, who, it was subsequently determined, did not have the disease.

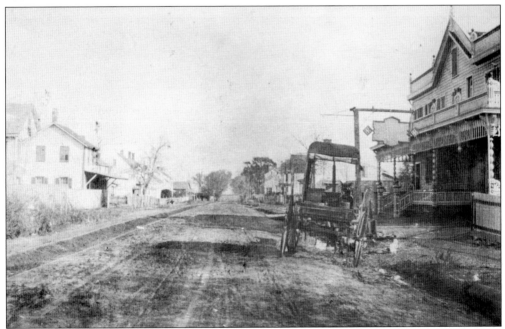

The wide dirt road in this undated photograph is Jackson Street, named for Andrew Jackson, likely during or shortly after his presidency. The view is toward the river from the area near Gordon Street. The large building on the right with the buggy in front is the Railroad Hotel, owned by Thomas Daly.

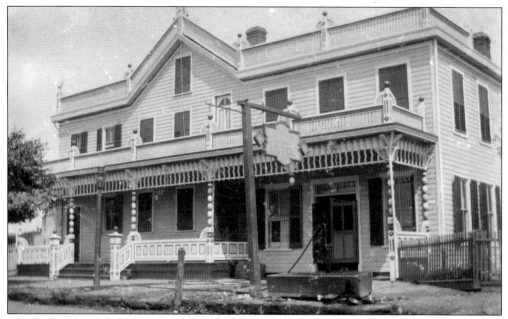

The Railroad Hotel, located near the bend in Jackson Street, was established in the 1880s by Thomas Daly. It is pictured here on June 7, 1898, six months before Daly's death. His widow, Mary, retained ownership until it burned in 1908, and William Goggin took it over after it was rebuilt later that year. The location has more recently been home to an A&P, Smitty's Cabaret, and El Tenampa Bar.

Patrick Allen's residence was at the corner of Jackson and Obert Streets, not far from Daly's Railroad Hotel. Built in 1903, it was photographed on April 13, 1906. Allen owned property that included multiple houses and barns, and he used his own horses and equipment in his work as a teamster. He was a member of the fire department and also had an early automobile garage on his property.

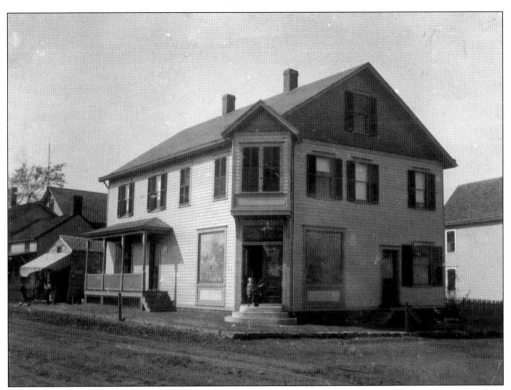

Edward Splatter ran this grocery store at the corner of Jackson and Obert Streets from the late 1800s until about 1910. It was photographed on October 19, 1901, the year that the house at the rear was added. The house burned in 1905, leaving the store relatively undamaged. A bakery stood on the site before the grocery. The building is best remembered as Smacker's Inn, operated by Blanche and Joseph Sokoloski.

Gottlieb Fehrle's grocery, news, and stationery store on the corner of Jackson and Obert Streets is shown here in July 1901, shortly after it was built. Fehrle also ran the saloon in the Union Hotel on Main Street after John Eppinger's death in 1905. A native of Germany, he was a liquor dealer and part owner of the Washington Embroidery Company prior to his death in 1917.

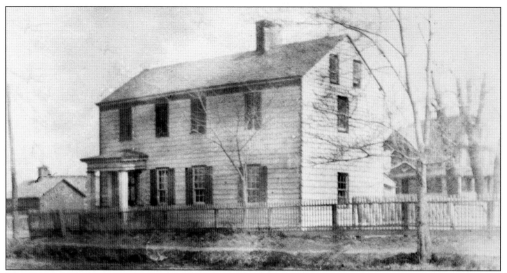

This undated photograph shows the Samuel Willett residence on Jackson Street. It was torn down in the early 1900s. Because there was more than one Samuel Willett and little information about the house, it is uncertain which family member owned it. What is certain is that one of the earliest names for South River was Willettstown. It was named in honor of an early Willett who settled here in 1720.

The Asher W. Bissett residence, pictured here on May 9, 1899, was located on Jackson Street in the area where St. Mary of Ostrabrama Church is located. Bissett married Anna Klauser, the daughter of Ambrose and Pauline Klauser, in 1907. In addition to his ice and coal business, Bissett ran a bologna factory in town and was active in local government.

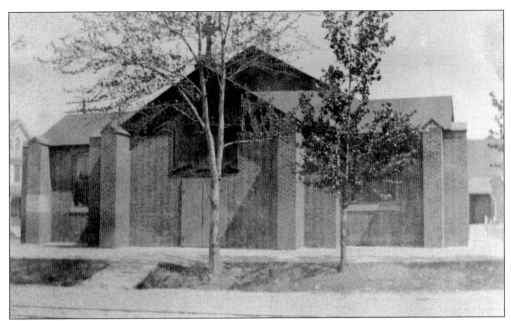

Established in 1902, the parish of St. Mary of Ostrabrama celebrated its first mass in the Bohi embroidery factory on Water Street. In 1903, property was purchased at the corner of Jackson Street and Whitehead Avenue, and construction of the church building was begun. Until 1908, when sufficient funds were raised to complete the building, the basement level, seen in this undated photograph, served as the church.

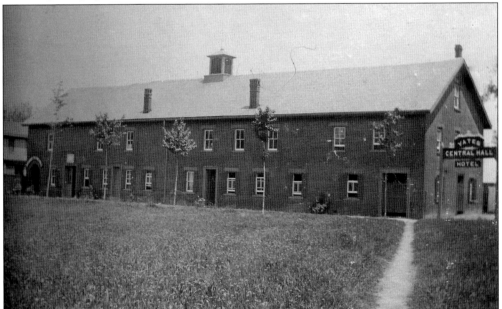

Yates Central Hall, located on Jackson Street near Ferry Street, was photographed on June 7, 1898. Built by brickyard owners Samuel and William Yates, it was managed by Edward Nugent for several years and hosted weddings, balls, political events, concerts, dances, vaudeville programs, and occasional borough council meetings. The Wilus family eventually bought it and renamed it Wilus Hall. It was later converted into the Portuguese Fisherman restaurant.

Until her death at age 91, Sarah T. Martin made her home in what became known as "The Castle," located at the corner of Jackson and Water Streets. The widow of Daniel Bray Martin, she died in 1908, leaving her daughter Mary Elizabeth Brown the executrix of her estate. Her obituary describes her as having "possessed an optimistic disposition which endeared her to all." Sarah's husband died in 1867 after having served in the US Navy during both the Mexican and the Civil Wars. He was appointed engineer-in-chief of the US Navy Department in 1853. Members of the Martin and Brown families lived in the house throughout its long history, and the area was often referred to as Brown's Corner. The residence was demolished in December 1965 in preparation for the erection of the Pulawski Savings and Loan Association building.

Four

DOWN THE ALLEY

This undated photograph is a view of the rear section of the Herrmann, Aukam, and Company handkerchief factory complex, as seen from the Raritan River Railroad bridge. The wings with their distinctive towers were added to the existing complex in the early 1890s. The top of one of the towers is just visible above the rightmost building in the photograph.

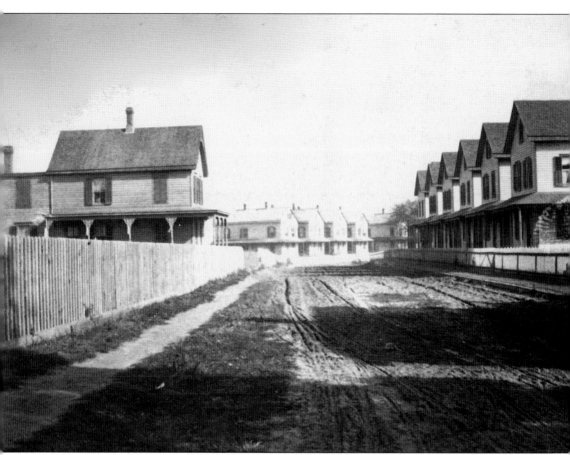

The row houses on Herrmann Avenue, now called Herman Street, were built in the 1890s and owned by Herrmann, Aukam, and Company. They were rented to company employees and finally sold as individual homes in 1938, along with a group of similar houses on Whitehead Avenue. The sales brochure for the public auction explained that the South River Spinning Company, a division of Sidney Blumenthal and Company, "considers that the ownership of dwellings for its employees is no longer necessary to the operation of their mills." Several of the houses were damaged during Hurricane Sandy in 2012, sold, and scheduled for demolition as part of the Blue Acres program. Herrmann, Aukam, and Company maintained a factory in South River from 1882 until 1918. The company manufactured various types of handkerchiefs and was the largest employer in the borough until labor disputes prompted its relocation to Pennsylvania. The factory complex was used by a variety of companies until 1969, when a major fire destroyed the older building.

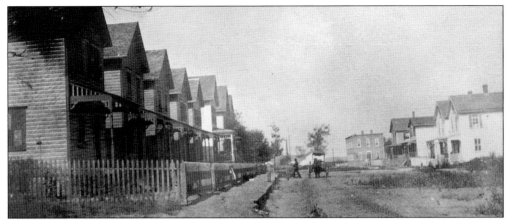

The view of Water Street looking toward the Causeway and the river beyond is the subject of this photograph taken on September 25, 1901. The five houses in the left forefront are identical, much like those built as employee housing on Herrmann Avenue. In subsequent years, the landscape of Water Street was greatly changed by the addition of several large factories.

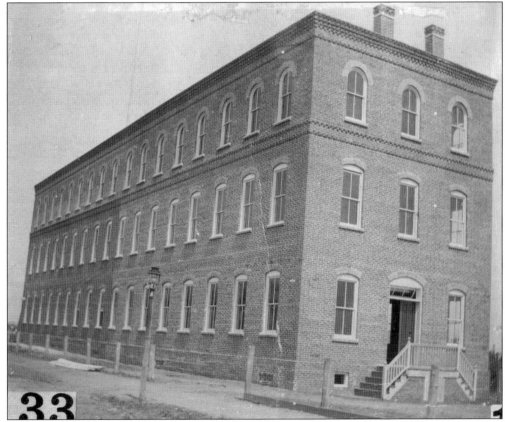

Alois Bohi Sr., a stitcher with Herrmann, Aukam, and Company, established his own business on Water Street. It was photographed on August 14, 1902, shortly after the building was completed. He trained his children in the industry, and the family managed eight factories in the borough during the first half of the 20th century. The building burned in 1926 and was replaced by the Armstrong Sales Corporation automobile dealership.

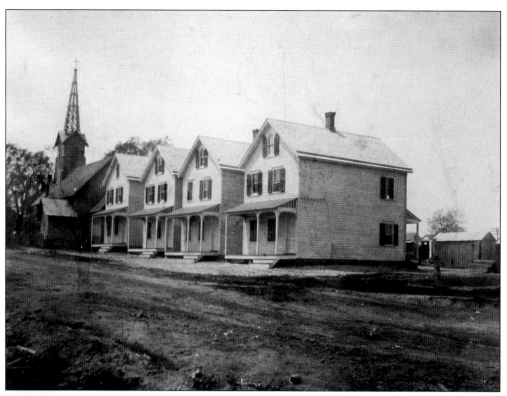

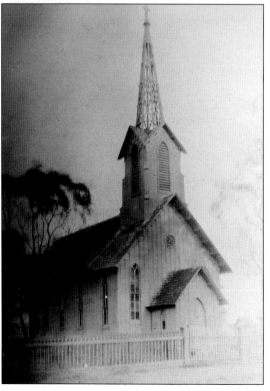

The distinctive steeple of the Episcopal church at the corner of Whitehead Avenue is prominent in this undated view of Martin Avenue from Water Street. In 1900, the residents of the street included the families of embroidery workers such as Charles Knapp, George Wickert, and William Crawford. The families of Marcus Wright, a mason, and John Shepp, a baker, also had homes there.

Erected on the corner of Whitehead Avenue and Martin Avenue in 1867, the Episcopal church building, which became Holy Trinity Episcopal Church, was originally constructed and used for services in Sayreville. With the approval of the founding parish, Christ Church of South Amboy, it was dismantled and rebuilt in South River on land donated by Capt. Daniel Bray Martin. The church is shown here on November 12, 1894.

The residence of Samuel and Lavinia Gordon was located on Whitehead Avenue, near the spot where St. Mary's Church was built in the early 1900s. The side view was taken in April 1895 and the front view on November 14, 1898. The house was eventually torn down to accommodate the parking lot for the church. Gordon served two terms as postmaster, beginning in 1905. During the Main Street fire of 1908, he saved the stamps and money from the post office before Citizen's Hall, the building in which it was located, burned. His career also included hotel keeping and banking, as well as involvement in local government, such as service on the board of public works.

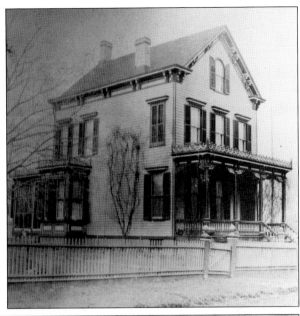

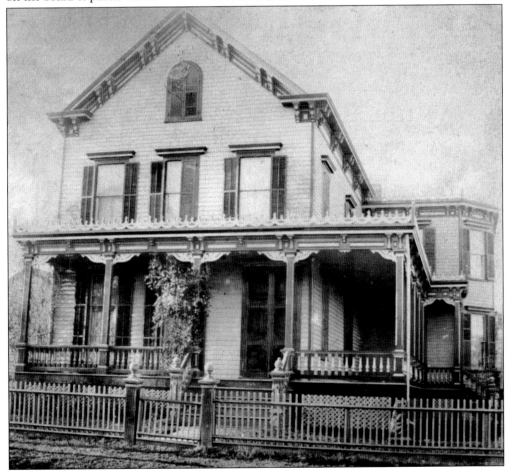

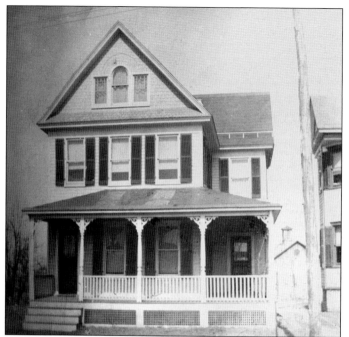

William S. Roth's home, located on Whitehead Avenue near Jackson Street, was photographed on March 30, 1904. A 1905 news item notes, "Doubtless the most unique Christmas tree around town is that which graces the parlor of Mr. and Mrs. William Roth, because it is lighted by colored electric lights and makes a beautiful appearance at night." His Main Street store included electrical supplies, bicycles, and automobile and bicycle repair.

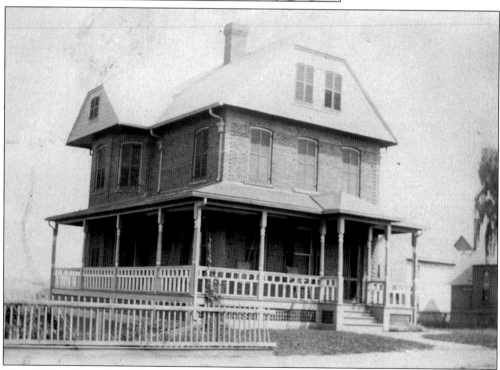

The William Franklin Gildersleeve residence, near the Roth home on Whitehead Avenue, is shown here in May 1901. Gildersleeve married Adelaide Coburn in 1893, and Charles Russell Gildersleeve was born two years later. The house was sold to the St. Mary of Ostrabrama Roman Catholic Church and converted into a convent. Sold again in 1924, it became the home of the Trojanowski family.

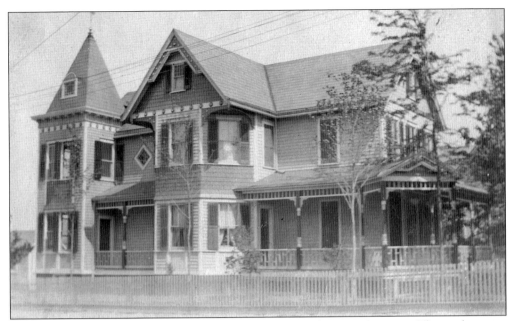

Alois Bohi's home was built on the corner of Whitehead and Martin Avenues. Of special interest are the tower and the ornamented gable in this photograph taken on May 22, 1905. Bohi was a Swiss embroiderer who worked for Herrmann, Aukam, and Company before establishing his own businesses. The house later became the residence of Matthew Maliszewski, an undertaker and bank executive in the borough.

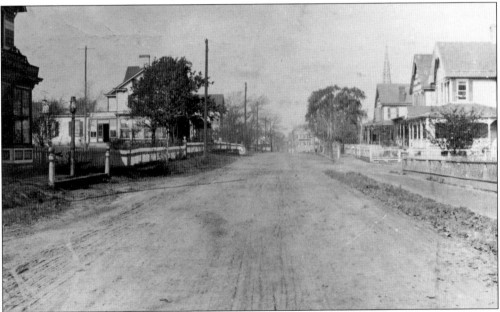

Photographed on November 4, 1898, this view shows Whitehead Avenue looking north toward Jackson Street from what was then known as Yates Lane. The building in the left forefront is Whitehead's print shop and store. Across the street is the home of Elwood Serviss, at the corner of Whitehead Avenue and Elizabeth Street. The corner of Martin Avenue is marked by the steeple of the Episcopal church.

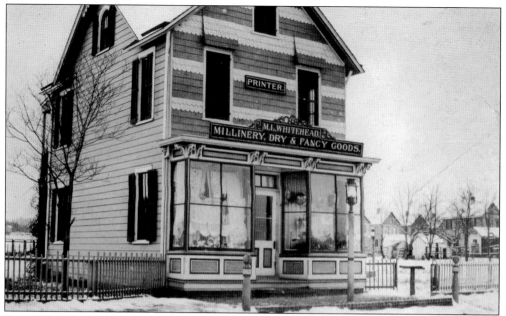

Samuel R. Whitehead and his wife, Maria L. Van Doren, were an enterprising couple. They owned the M.L. Whitehead Millinery, Dry, and Fancy Goods shop on Whitehead Avenue, pictured here on January 8, 1896. The small sign between the windows is the only indication that Samuel had his printing business in the same building. He was the only printer in town from the late 1890s through the early 1920s.

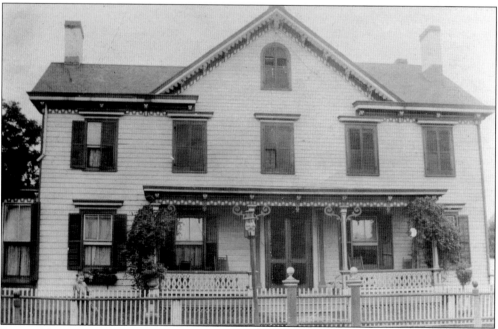

Pictured here on July 29, 1897, is the Whitehead Avenue residence of Samuel R. Whitehead. It eventually became the Maliszewski Funeral Home. Samuel was the maverick in the Whitehead family. Instead of working in the clay and sand industry, he went into the printing business. He lived in the house with his wife, Maria, and their children.

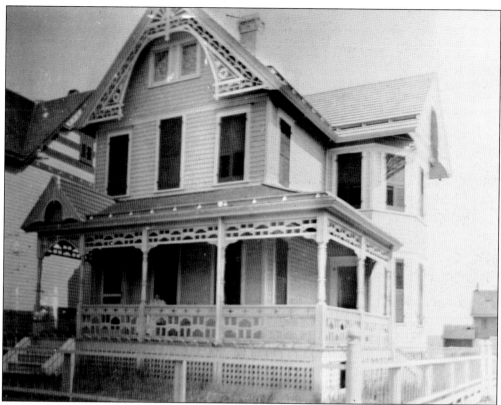

This September 12, 1895, image shows the home of Elwood Serviss and his wife, Amelia Klauser. The photograph was taken in the year they were married. Serviss was a mason and contractor. The house, located on the corner of Whitehead Avenue and Elizabeth Street, was later owned by the Hill family.

Pictured here in 1905 is the newly built embroidery factory of Otto Bohi and Joseph Lunepp, on Division Street. The Bohi family was large, and many of its members were involved in the embroidery industry. Lunepp married into the family; his wife was Lena Bohi, one of Otto's younger sisters. The family patriarch, Alois Bohi Sr., had a large embroidery factory on Water Street.

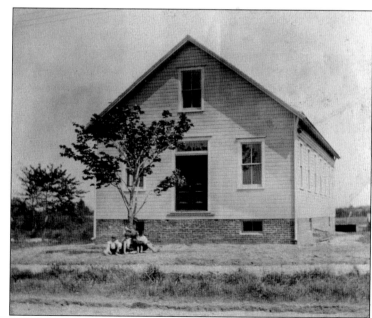

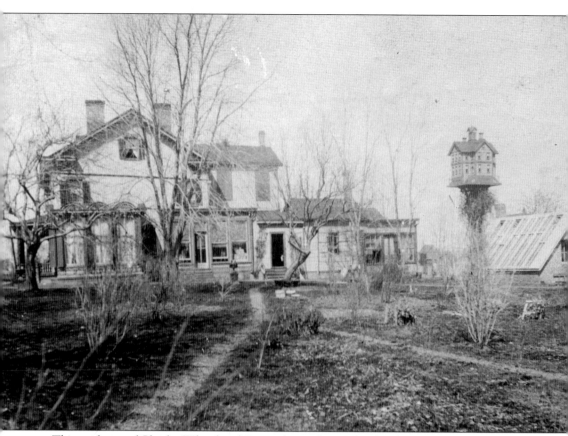

The residence of Charles Whitehead Sr. was located on Whitehead Avenue across from Charles Street. Although much altered, the building has survived into the 21st century. This February 16, 1892, side view also shows the greenhouse at the rear of the property. The eldest of the five Whitehead brothers, Charles headed the Whitehead Sand and Clay Company of South River, the largest concern of its kind in the United States at the time. In 1892, he formed the company into a family-owned stock concern. He was a charter member and officer of Lodge No. 28, Knights of Pythias, of South River, a fraternal organization dedicated to friendship, charity, benevolence, and universal peace. Known for his philanthropy, Whitehead was one of the most influential and successful businessmen in Middlesex County. He was married to Jemima Cozzens on February 21, 1851. They had five children—Samuel R., Charles Jr., Lavinia (the wife of Samuel Gordon), George (who died at age 18), and Edward.

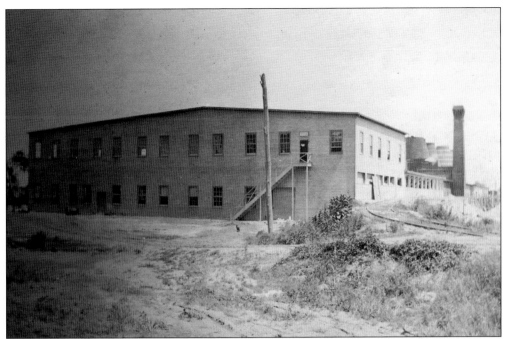

Incorporated in 1893, the American Enameled Brick and Tile Company was located on Whitehead Avenue near the Raritan River Railroad station. These photographs show the plant on July 16, 1902, and again with a large pile of broken brick and tile in July 1905. The main office was in New York, with Julius A. Stursberg as president. John Van Vorst Booraem was the vice president, and his son John Francis Booraem was the secretary and treasurer. The South River plant was supervised by Bernard Jacquart and later by his son. The company manufactured high-grade enameled brick and provided enameled tile for facing buildings, bathrooms, kitchens, laundries, hospitals, and subways. In 1934, the complex was destroyed by fire.

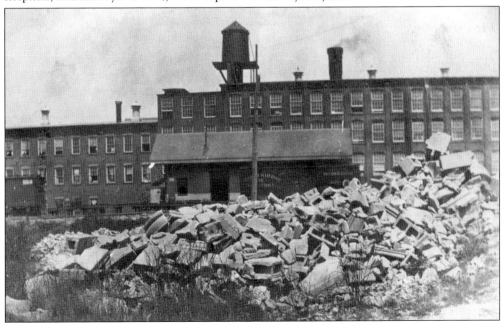

The Raritan River Railroad Hotel, established by Forman C. Bissett around 1896, was located on Whitehead Avenue, near the railroad tracks. Bissett was an ardent automobilist, and by 1910 he had expanded his suburban hotel to more than 20 large rooms, a bar and dining room, a bottling business, and a dance pavilion. The structure, pictured here on September 25, 1901, was eventually converted into an apartment building.

Andrew Schmitt's residence, located at the corner of Whitehead Avenue and Serviss Street, is pictured here in June 1902. Schmitt, an embroidery stitcher from Germany, later owned a barbershop on Jackson Street. By 1930, an addition had been made to the house, and the original section was a funeral home. The wedge-shaped portion of the addition became a store. In later years, the Liberty Ballroom found a home there.

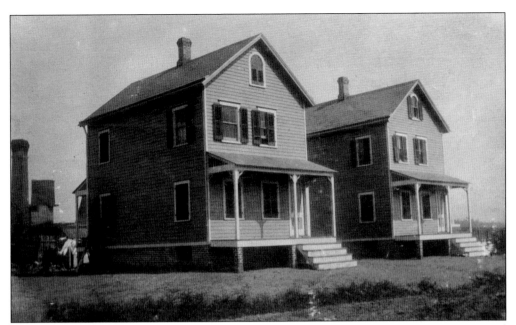

These two houses, photographed on September 25, 1901, were owned by James E. Serviss and located on Prentice Street, later renamed Serviss Street. Near several factories, they were most likely investment properties intended as housing for the workers who lived in the area. Serviss himself lived on Main Street. He married Susan Augusta Throckmorton in 1904 and died in 1940, two days before his 83rd birthday.

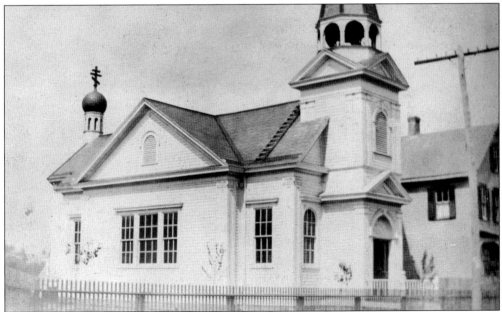

This May 1906 photograph shows the original SS. Peter and Paul Orthodox Church on Whitehead Avenue less than a year after completion. In 1913, it was moved and raised one story. Three years later, in June 1916, the building was struck by lightning and burned. The *New Brunswick Times* reported that services would be held at Schack's Hall until repairs could be made. A brick church was completed in 1918.

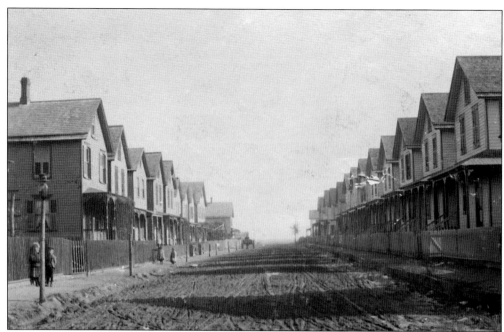

This undated streetscape is a view of Levinson Avenue from Whitehead Avenue. The street was named for Jacob Levinson, a prominent local businessman. The four children on the walkway at the left are likely from families that lived in the virtually identical houses that lined the street. Many of the residents would have been employed in nearby factories.

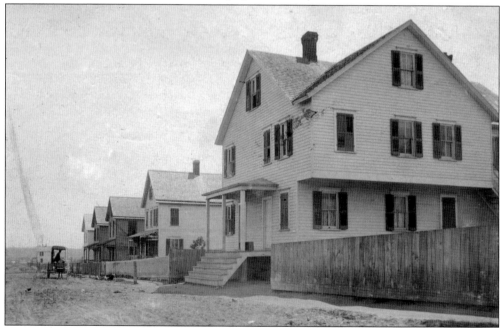

The 1904 Sanborn map shows only five buildings on Armstrong Avenue, the same five that are visible in this undated photograph. By 1910, additional structures had been added, including a saloon owned by the Olchaskey family. Located at the corner of Armstrong and Whitehead Avenues, it later became O'Neill's Tavern and the Gold Star Bar.

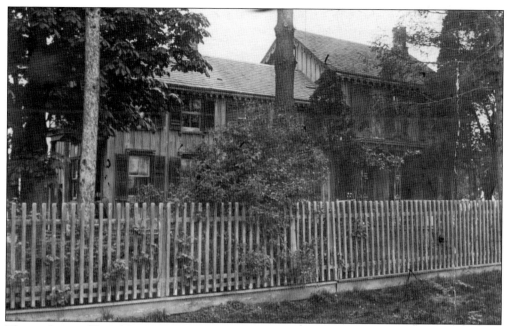

The residence of David Armstrong Sr., pictured above on May 13, 1899, was located at the juncture of Whitehead Avenue and Augusta Street. The house was built in the late 1800s for Armstrong, his wife, Mary, and their nine children. The children included future mayor James B. Armstrong as well as a daughter, Jean, who would marry Jesse Selover. Armstrong, a farmer, sold the land to Alexander Schack in 1904. Schack's Hall was subsequently built, and the adjoining pavilions and grounds, shown below in May 1906, were used for outside activities. Schack's was a second home for Polish and Russian brick laborers. Polkas and waltzes were played on violins and accordions for banquets attended by as many as 450 people. The structure burned in 1953 and was rebuilt. The Ria Mar Restaurant and Bar opened in the same building in 1987.

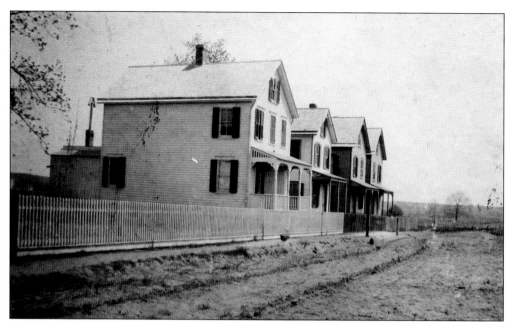

This May 7, 1900, view of Augusta Street from Whitehead Avenue shows the land next to the Armstrong farm and the future site of Schack's Hall. The visible houses are all similar in design, as were many of the residences built on streets off Whitehead Avenue during the same period. Many of them became homes for Russian and Polish immigrants who worked in the local factories.

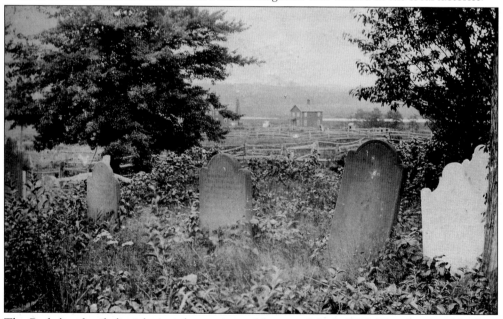

The Barkelew family burial grounds are pictured here on July 8, 1896. The plot dated back to the 1700s and included Abraham, Ann, Stephen, Isaac, and Abraham S. Barkelew, as well as Anne Sherer. This family plot was typical of burial practices before the development of church and large community cemeteries like Washington Monumental Cemetery. The graves were eventually moved, and the land is now owned by the Belarusian Greek Orthodox Church of St. Euphrosynia of Polotsk.

Five

ON WATER AND ON WHEELS

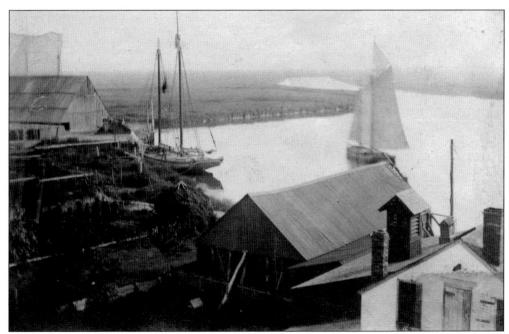

This August 3, 1896, view of the South River was taken from the roof of the American Hotel. The Booraem Brothers shipyard, near the bend on Reid Street, is partially visible, along with two ships that were likely built or repaired there. A portion of one of the sheds at John Whitehead's brickyard can also be seen. The buildings in the foreground were part of the hotel property.

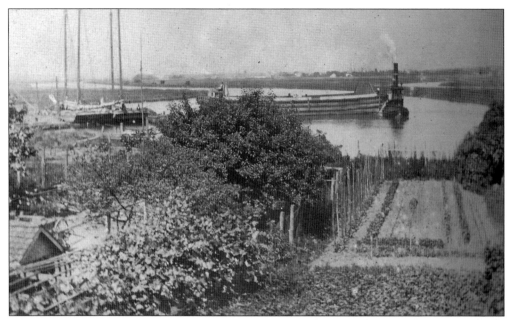

The tugboat in this photograph was likely pulling the barge already loaded with brick when the barge ran aground on a sandbar on May 15, 1906. John Whitehead's brickyard was in proximity on Reid Street. It later became the South River Brick Company and eventually the location of the Lyons Shepsco Veterans of Foreign Wars Post No. 1451. The two-masted ship is docked at the Booraem Brothers shipyard.

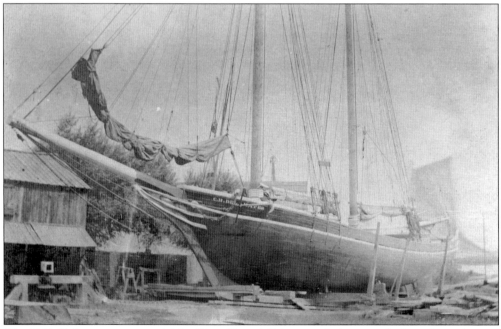

The *C.H. DeLamater* was owned by Capt. Daniel Selover and photographed on the railway at the Booraem Brothers shipyard in September 1900. When a crew member fell overboard and was rescued in December 1901, the *New Brunswick Daily Times* reported that the schooner was "lying at South Amboy, waiting to be loaded with coal for Theodore Willett, of South River."

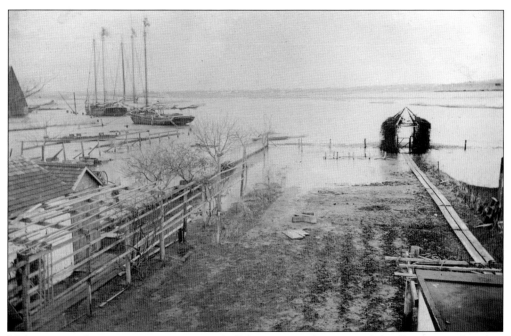

Melting snow from a severe storm in early February was the cause of the flooding, referred to as a freshet, evident in this photograph of the riverfront. The image was captured just before sunrise on February 7, 1896. The view is looking across the river toward Sayreville from one of the properties along Reid Street.

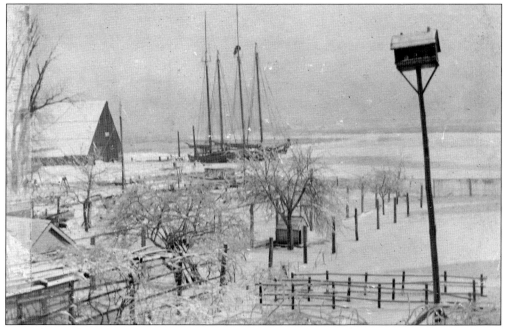

A sleet storm that started on February 21, 1902, and continued the following day created this picturesque view taken from Reid Street. The newspaper reported that the storm was so severe that the trolley from South River was unable to make it to New Brunswick, and 14 men and women took shelter in the Milltown powerhouse overnight.

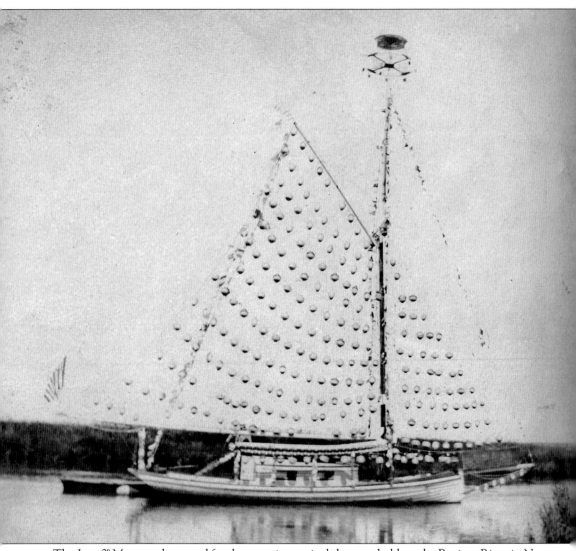

The *Inez & May* was decorated for the aquatic carnival that was held on the Raritan River in New Brunswick on August 22, 1895. Entered on behalf of the Columbia Yacht Club of South River, the yacht was owned by Asher W. Bissett and won first prize in the competition. The elaborate design included more than 350 Japanese lanterns, in various colors and sizes, strung on wires and arranged in the shape of the mainsail and jib. The *Special Carnival Edition* of the *Daily Times* of New Brunswick reported, "At the top of the mast, high in the air, was a revolving tower, on each end of which was a miniature production of the big sloop itself." The yacht was manned by members of the yacht club dressed in white duck. Members of the Columbia band, associated with the club, rode along in full uniform.

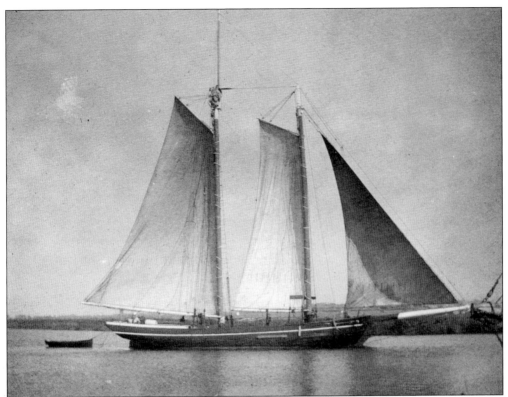

Sloops, schooners, barges, and pleasure boats were once common sights on the South River. The two-masted schooner *Extra* was photographed in full sail on September 26, 1895, as it traveled on the river. The vessel delivered cargoes of coal to various locations, including the riverfront sheds of Frederick W. Bissett, owner of a general store on the corner of Main and Ferry Streets.

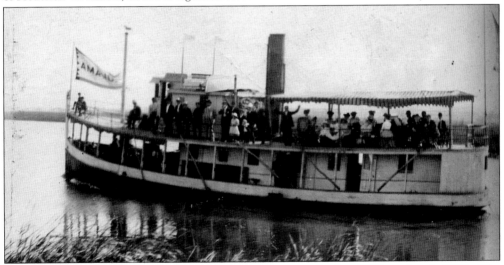

Excursions from South River were a regular occurrence in the late 1800s and early 1900s. The steamer *Amanda*, captained by Alvie Peterson, is shown here on August 26, 1902, as it prepares to leave for North Beach, a popular resort near New York City. The trip was sponsored by the Marine Pleasure Club of South River.

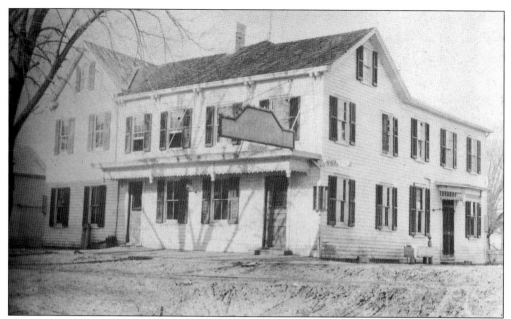

The South River Hotel, also known as Klauser's Hotel, was purchased by Ambrose Klauser in the early 1870s. Photographed on January 20, 1899, it was located at the river end of Klausers Lane. The family is said to have counted the people getting off the steamships in Sayreville to determine how many beds to make up. The hotel included a bowling alley, offices, and meeting rooms. It burned in 1967.

This undated photograph of the eastern end of the Causeway was likely taken in 1895, when the trolley line was being installed. The tracks end abruptly, and the poles are bare of wires. During the early 20th century, the area became popular with the African American population of the borough. Many of the residents were part of the final wave of employees in the brick industry of South River and Sayreville.

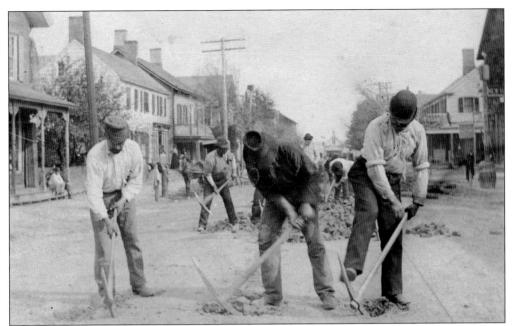

After months of discussion, an ordinance granting the Brunswick Traction Company a franchise to lay its track and operate a trolley through South River was passed on September 24, 1895. Work began the next morning according to the *Daily Times*, which reported that "the task of laying the tracks and erecting the poles began with zeal." These two images were captured on lower Main Street on October 26, 1895. The photograph above shows workmen digging for the trolley road, and the photograph below captures the beginnings of the work to grade the roadbed. The Riverside House, located at the foot of Main Street, where the Veterans Memorial Bridge now sits, is visible in the background of both images. The Washington Hotel, near Ferry Street, is the last building visible on the right.

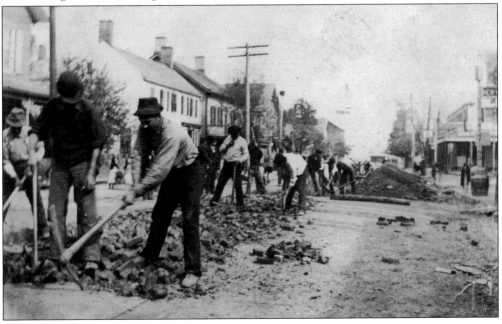

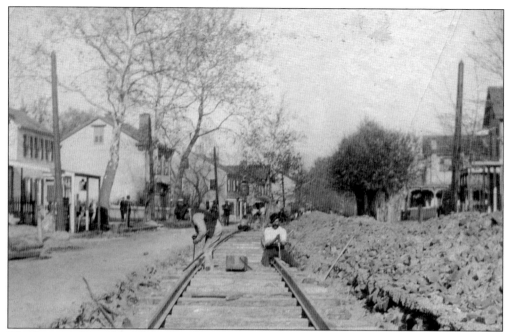

The five members of the town committee voted 3-2 to allow the trolley to come through South River. The route ran down Main Street to Ferry Street and from there to Jackson Street and the Causeway before continuing into Sayreville. This October 1895 view of Main Street looking east toward the river from Thomas Street shows the rails being laid.

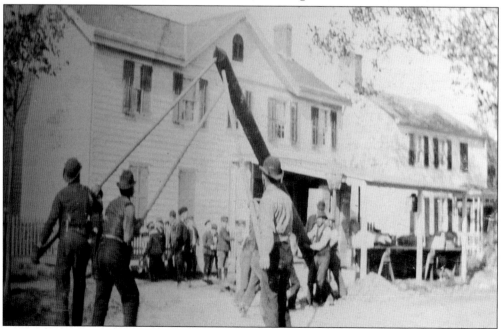

A team of workers is pictured here raising the poles for the trolley wires while a group of local boys looks on. The view shows the buildings at the bend of Main Street, above Thomas Street, opposite the residence of John B. Tuttle. The larger of the two visible buildings is divided between a residence and a grocery store.

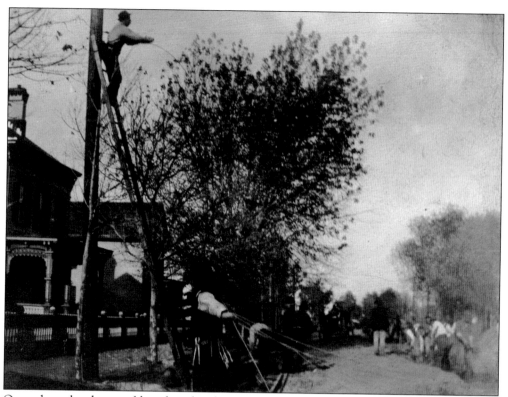

Once the poles that would anchor the electric wires to run the trolley were in place, the wires themselves went up. One workman perched precariously at the top of the ladder while those on the ground kept the wires in order. The photograph was taken on Main Street in front of the residence of Charles Whitehead Jr.

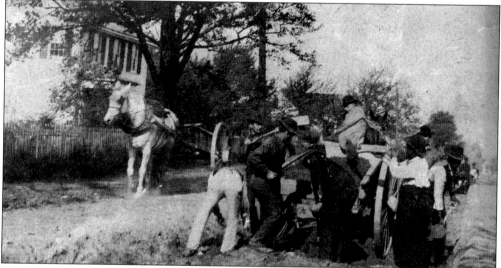

Work on the trolley road continued up Main Street on October 26, 1895, as shown in this photograph taken opposite the residence of Charles F. Simmons on upper Main Street, near Pierson Street. Workers are seen shoveling dirt as part of the grading process. Once the trench was dug and the roadbed properly graded, the rails could be laid.

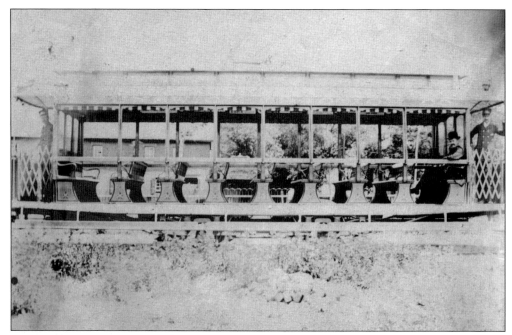

The official opening of the trolley line was in November 1895, although a test run took place in late October. According to the New Brunswick *Daily Times*, the first trolley arrived at South River at 3:01 p.m. on Saturday, November 2. The summer trolley, seen here on June 1, 1896, and again on July 11, 1902, had open sides to provide for ventilation. The above photograph, the older of the two, was taken at Yates Corner, the junction of Ferry and Jackson Streets. Yates Hall, which later became the Portuguese Fisherman restaurant, is visible in the background. The 1902 photograph below was taken on Main Street, perhaps near the trolley waiting room, which was reported to have been located in George Radcliffe's confectionery store in 1901.

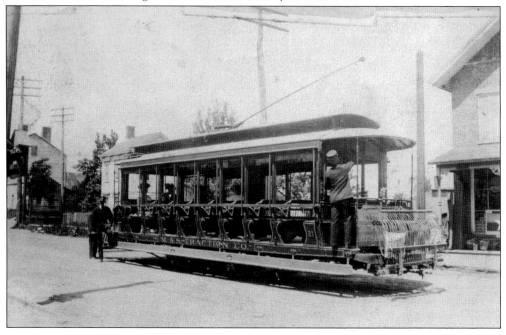

Posing with their bicycles on July 17, 1897, are Harriet Gordon Levy, her sister, Dora Gordon, and fellow resident of Main Street Reva Vliet. Two days before the photograph was taken, Vliet was in court being sued by Mary Gilliland over the cost of a bicycle wheel. The jury ruled in Vliet's favor.

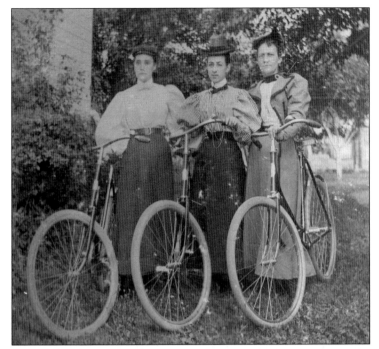

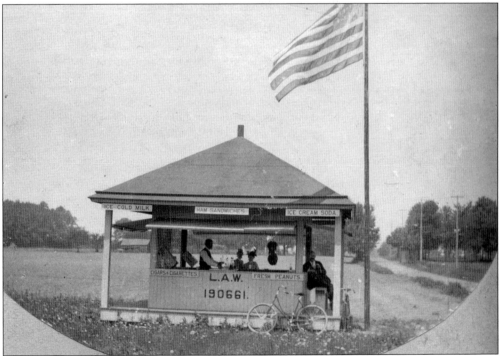

This June 6, 1898, view shows a small concession stand known as the Wheelman's Rest, which was run by Joel C. Perry and said to have been located east of Tanner's Corner on what became Old Bridge Turnpike. The League of American Wheelmen, the "L.A.W." on the sign, was founded in 1880. Bicycle clubs became increasingly popular in subsequent years. Perry also owned a confectionery store on Main Street.

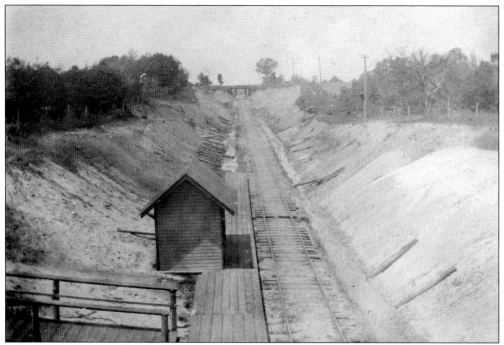

The advent of the Raritan River Railroad transformed industry in the borough by shortening the delivery time for raw materials and supplies and making it easier to ship out finished products. It also provided new outlets for locally produced items such as bricks and embroidered apparel. The photograph above shows the view looking west from the bridge on Main Street on June 6, 1898. Another bridge over the railroad tracks is just visible in the distance. The photograph below is an undated view of the 265-foot railroad frontage for Clayton and Pierson's lumberyard, later Clayton Lumber Company. Many major industrial plants in the borough had railroad frontage during this time period.

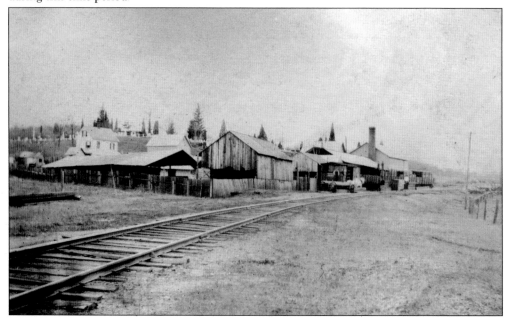

Six

Up the Hill

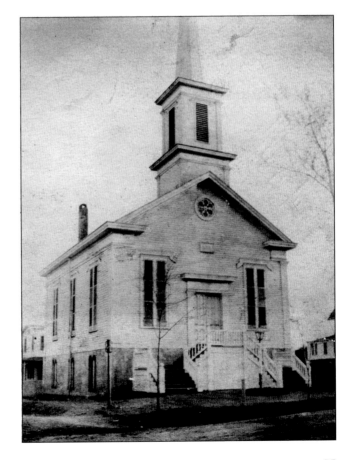

The cornerstone for the Methodist Episcopal church, located at the corner of Main and Gordon Streets, was placed in 1858. The church was renamed in honor of a donor and eventually became the Conklin United Methodist Church. It is shown here on November 20, 1894. In 1941, the wooden building, with its tall steeple and dual front stairways, was torn down and replaced with a new brick edifice.

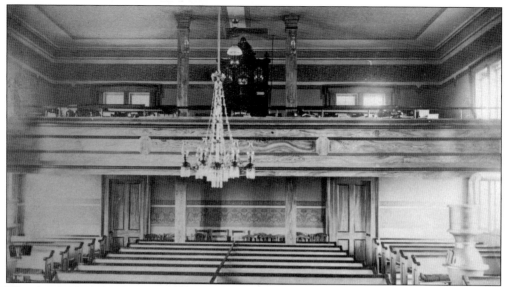

This April 16, 1893, photograph shows the interior of the Methodist Episcopal church, with a view looking toward the gallery with its elaborate pipe organ. The main room featured wooden pews with cushions, decorative wallpaper borders, and matching potbellied stoves on either side. An entry to the belfry and steeple is visible above the organ, and the bell rope extends down through an adjacent hole in the ceiling.

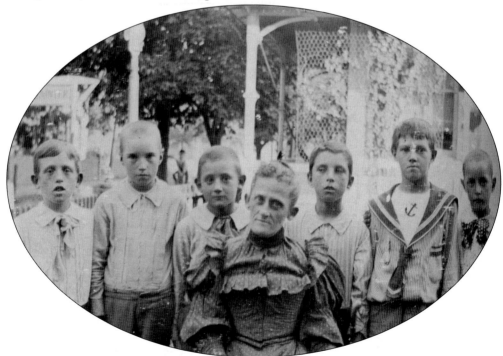

Irene Booraem was the daughter of Thomas Booraem, a ship's carpenter, and Ellen Perrine of Main Street. She is pictured here on September 12, 1895, with the six students in her class at the Beacon Light Methodist Episcopal Sabbath school. As a child, she was a student in the same Sunday school. During a two-day program in 1863, she represented Florida in a piece titled "Secession."

George P. Farr's residence was located next to the Methodist Episcopal church. The two were photographed on March 6, 1897. Although the church has been razed and rebuilt since the image was captured, the house has survived into the 21st century looking much as it did more than 100 years ago. The 1900 census identifies Farr as a foreman at the Herrmann, Aukam, and Company handkerchief factory.

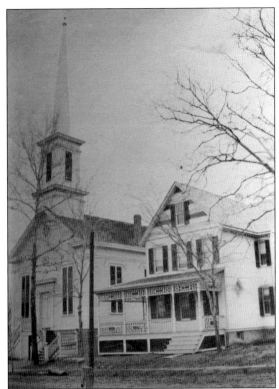

On January 21, 1902, the roof of Nathan W. Clayton's residence at 98 Main Street must have provided an excellent view. Clayton was the owner of a lumber company and president of the First National Bank of South River for a time. His company provided worker housing, jobs for area residents, and wood products for businesses and homes. His house later became the office of Dr. Hans R. Gandhi.

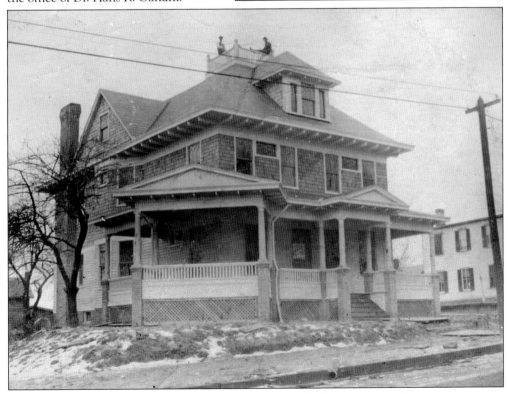

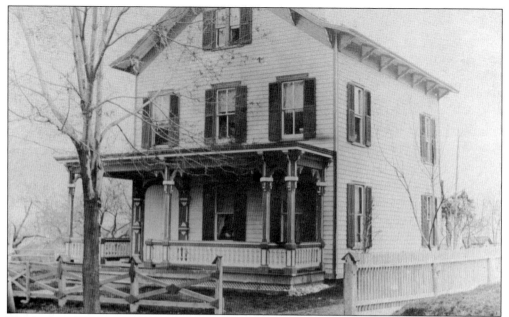

The home of Samuel Willett Booraem, next to the Clayton residence, was photographed on April 20, 1894. In later years, after the erection of several additions, it became known as the longest house in town. Booraem was a prominent member of the community, having served as town commissioner, president of the building and loan, and president of the board of education. Booraem and his wife, Phebe, both died in 1901.

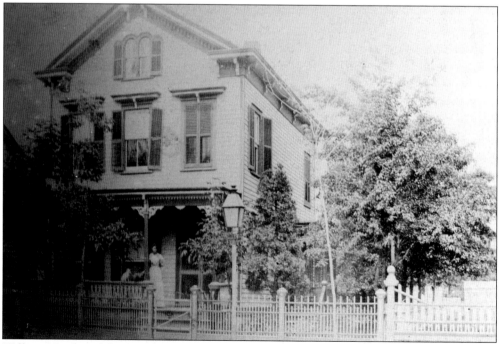

William Van Zant (often spelled Van Zandt) was a wheelwright by trade. He was married to Julia Smith. His house, seen here in June 1894, a year after Julia's death, was located on Main Street across from Gordon Street. Dr. Charles B. Burnett boarded with the family for a time.

Located at 119 Main Street, on a lot purchased from John Whitehead, this Methodist Episcopal church parsonage replaced an earlier one that was located farther up Main Street. The Rev. S.K. Moore was pastor at the time. Erected and photographed in 1901, the structure became home to a series of small businesses in later years, although without the elaborate porch that originally graced the building.

Before the new building was constructed in 1901, the Methodist Episcopal church parsonage was located at 123 Main Street, although house numbers were not actually used in that era. This March 25, 1892, image was taken during the pastorate of Rev. William G. Moyer. The home was repaired and the porch extended after the new parsonage was built.

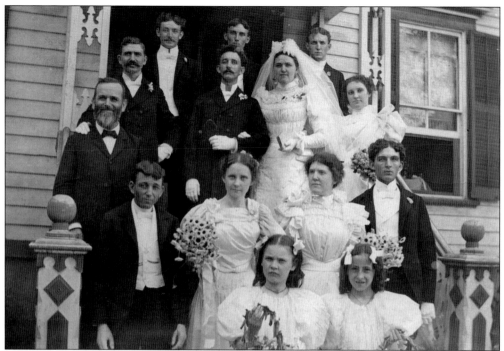

The wedding of Lizzie Hagaman and William Izard Garrison took place at the Methodist Episcopal church, later Conklin United Methodist Church, on June 30, 1897. The bridal party paused on the steps of the parsonage on Main Street for a portrait. Rev. Ulysses Grant Hagaman, brother of the bride and pastor of the church, performed the service along with Rev. W.E. Greenbank.

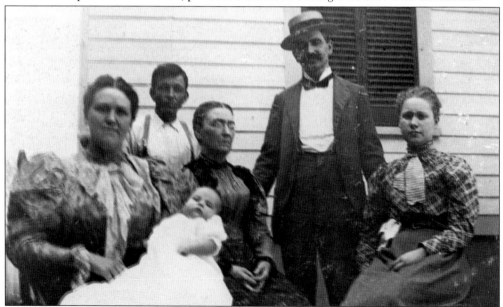

Rev. Ulysses Grant Hagaman (standing) was appointed pastor of the Methodist Episcopal church in 1896 and served until 1899. On June 30, 1898, he posed in front of the parsonage with his family. At the left is his sister Lizzie Garrison with an unidentified infant and at the right is his wife, Harriet. The other man and woman are believed to be his brother Charles and his mother, Susan.

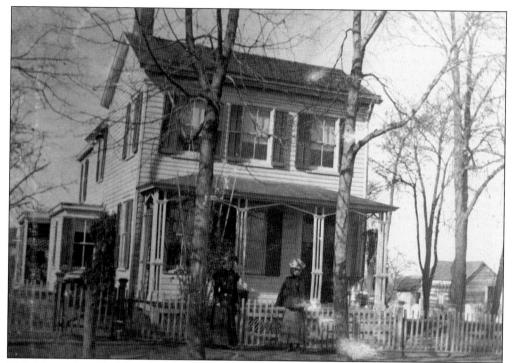

This November 20, 1901, photograph shows the residence of DeWitt C. Rose, captain of the schooner *Telegraph*, according to a 1903 newspaper article. A boatman for most of his life, he later served as South River's overseer of the poor. He lived on Main Street near John Street with his wife, Violet. Of their 12 children, 8 were still living when the 1900 census was taken.

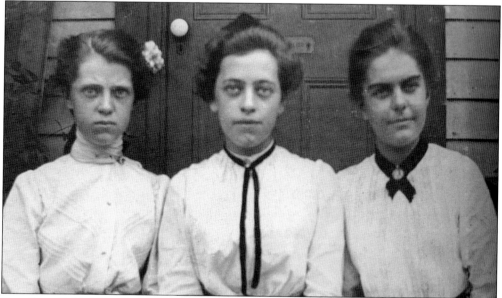

Kate Rose (left), Mary Rose (center), and Daisy Hatter pose for this photograph on August 13, 1901. Kate and Mary were the daughters of DeWitt and Violet Rose of Main Street. Daisy lived on Obert Street with her parents, George and Jane Hatter. Kate and Daisy, ages 19 and 15 respectively, worked as handkerchief operators, according to the 1900 census. Mary was still at school.

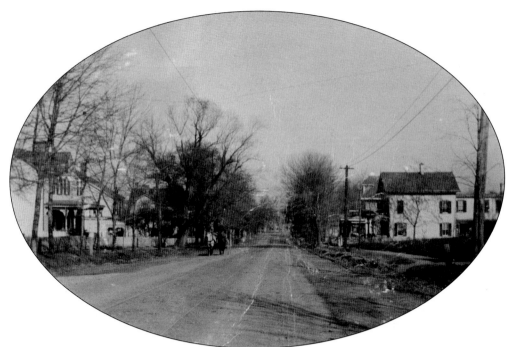

The view looking east from John Street is the focus of this November 21, 1898, photograph of Main Street. The home of Samuel Willett Booraem is visible on the right, with Nathan W. Clayton's house just beyond. Among the Main Street homes near John Street are those of Elvin Whitehead, Emanuel Bowne, William Morgan, Fannie Peterson, and Cassius Sperling, according to the 1908–1909 *South River Directory*.

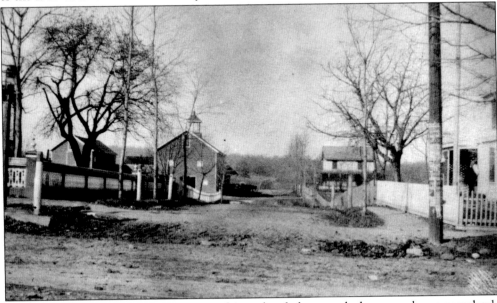

Taken from the Main Street intersection, this undated photograph shows an almost completely undeveloped John Street. After George Street was extended past Thomas Street in the latter half of the 19th century, John Street served as its end point and terminated at a point just beyond it. Fields and woods are visible in the distant landscape.

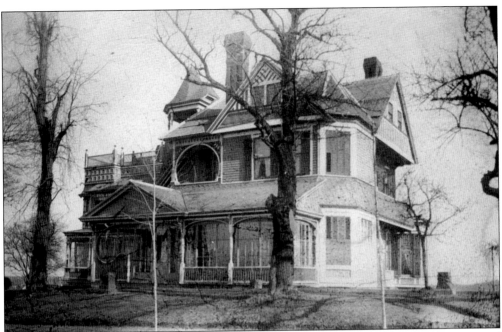

The residence of Charles S. Colwell, seen here on March 13, 1893, was located at the corner of Main and Jackson Streets. An 1887 article in the *New Brunswick Daily Home News* describes the housewarming party for the remodeled Queen Anne home that the family called the Hillside. It was destroyed on December 28, 1894, by a fire that was thought to have been started by a heater in the cellar. Colwell, a retired iron merchant, was visiting New York with his wife, Cora, and their daughter Edna when the fire took place. The property remained vacant until 1907, when Edward Whitehead built a new house on it for his bride, Kathryne Roller. That house was later sold and eventually became part of the property owned by the Tabernacle Baptist Church.

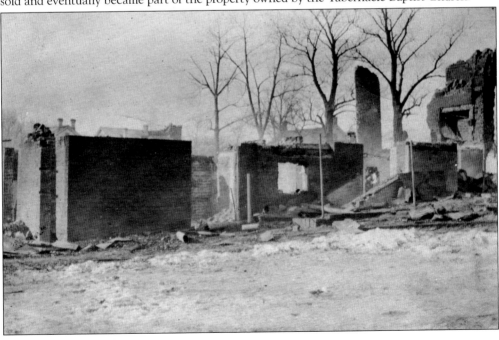

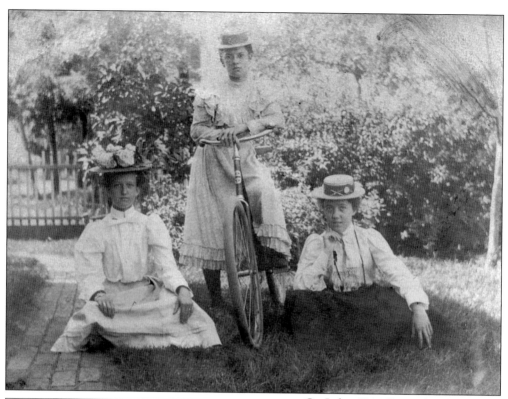

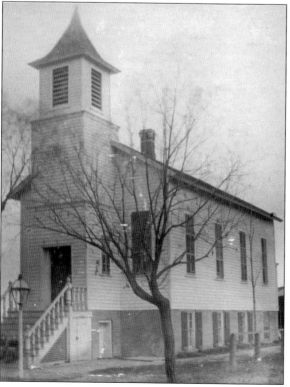

On Labor Day, September 5, 1898, Edna Mathews (left), Kathryne Roller (center), and Charlotte Schofield pause in their holiday activities to pose for this photograph. Edna and Kathryne were both members of the Silver Star Club, a social organization for the single ladies of the borough. Kathryne would later marry Edward Whitehead, who built the Whitehead house at 124 Main Street near the Jackson Street intersection.

Samuel Whitehead Sr. donated the land for the Tabernacle Baptist Church at the corner of Main and Jackson Streets. Dedicated in 1871, it was enlarged in the 1880s, and pictured here on November 12, 1894. In 1908, a new brick church was dedicated, and in 1960 it was replaced with a more modern structure. The two brick buildings coexisted until the older of the two was razed in 1998.

This Victorian home on upper Main Street, between Virginia Street and Wilcox Avenue, was owned by David Serviss and photographed on December 16, 1898. Married to Mary Throckmorton, Serviss was a surveyor by profession, but he also held positions as county collector and president of the First National Bank of South River.

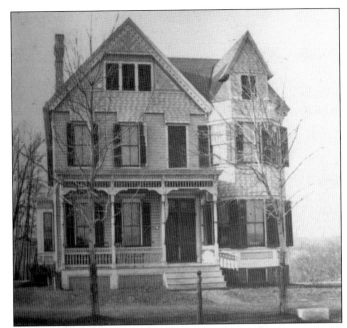

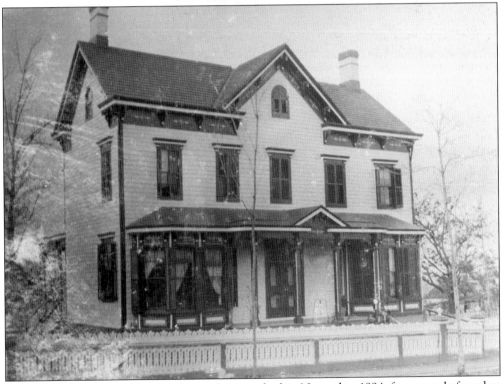

The residence of John Whitehead was photographed in November 1894, four years before that of his neighbor David Serviss. Whitehead retired in 1888 from the sand and clay business that was run by the Whitehead brothers. He started his own brickmaking business around the same time. Some years after the death of his first wife, Eleanora Yates, he married her sister, Sarah. He died in 1913.

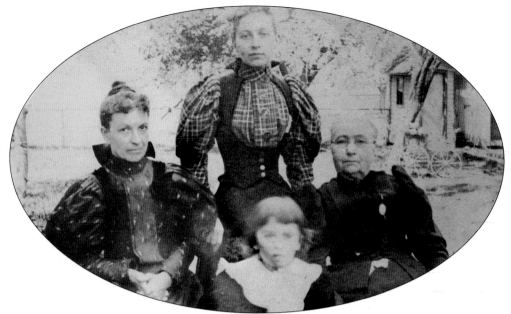

Four generations sit for this photograph on May 4, 1896. Pictured are, from left to right, (first row) Elizabeth Van Deventer, wife of Theodore Van Deventer, her grandson, Harold Phair, and her mother, Mrs. Dent; (second row) Alice Bertha Phair. Alice, the eldest of three daughters, married William Phair on November 5, 1890. She was widowed in 1899 and later married widower John C. Price.

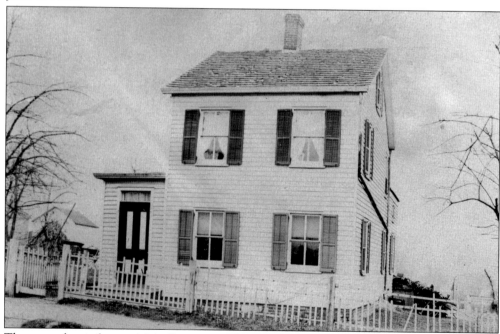

The steep slope of upper Main Street is evident in this May 9, 1897, photograph of the home of Theodore Van Deventer. In 1906, the rear portion of the lot, with frontage on upper George Street, was sold to John Dailey. Van Deventer, a boatman, was the son of Freeland and Adelia Ann Van Deventer. He died in 1908 at the age of 69.

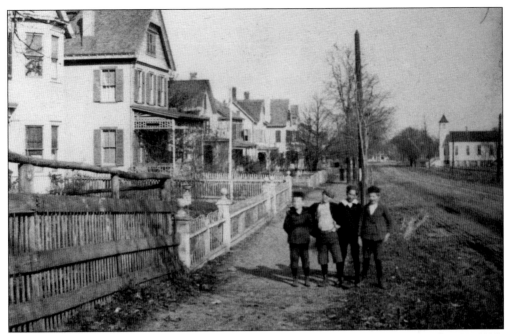

Four young boys are the focus for this view of Main Street looking east on November 21, 1898. The photograph was taken from a vantage point in front of the widowed Mrs. Gordon's residence, near the future location of Wilcox Avenue. The original Tabernacle Baptist Church at the corner of Main Street and Jackson Street is visible in the background on the right.

Bernard Jacquart and his wife, Margaret Dietz, built this handsome residence in 1901. A conservatory was added in 1903, and the house was photographed on May 8, 1905. Jacquart was the supervisor at the American Enameled Brick and Tile Company for many years and held several patents related to the production of enameled tile. He was also a director of the South River Trust Company when it incorporated in 1915.

Completed in 1905, Charles Henry Manahan's imposing residence was photographed on May 8 of that year. A November 14, 1904, article in the *New Brunswick Home News* describes it as "an architectural beauty second to none in town, and different in style from any of its predecessors." It included electric lighting and all the modern conveniences of the time. Manahan was a lumber man, contractor, and hotelkeeper.

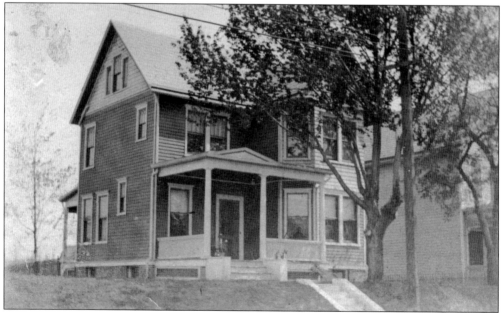

Farther up Main Street, past the homes of Bernard Jacquart and Charles Manahan, was the residence of Robert F. Fountain. This May 8, 1905, image shows a more modest house than those of his neighbors. Fountain worked for the First National Bank of South River for over 50 years and ended his career there as president of the institution, having managed it through the Great Depression and the postwar boom.

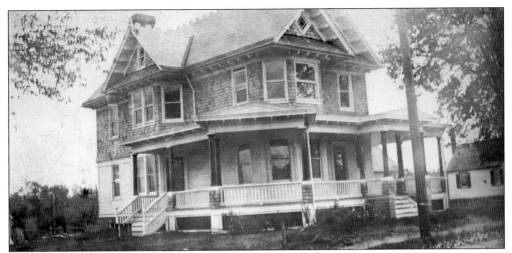

The corner of Main and Pierson Streets was the location for the residence of Elbert C. Pierson and his wife, Anna. The street that ran next to their home was named in his honor, and Pierson partnered with Nathan W. Clayton in the lumberyard that bore their names. Clayton eventually became the sole owner. In later years, the house was owned and occupied by the J. Randolph Appleby Jr. family.

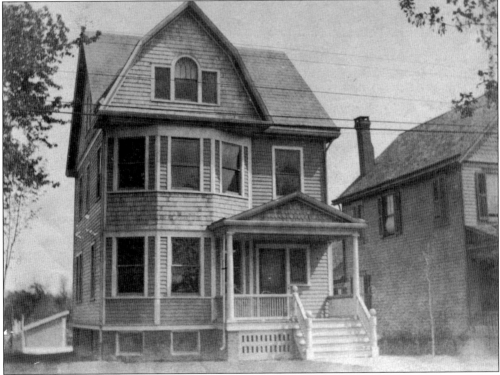

Chester Merton Sheppard resided near Pierson Street with his wife, Mary Kuhlthau, and their children. Sheppard worked in various capacities for the Raritan River Railroad. In 1914, C.M. Sheppard and Company was the successor to Andrew Church's feed and grain store at the foot of Main Street. The business was sold again in 1916 and became the South River Supply Company. The house was photographed on May 8, 1905.

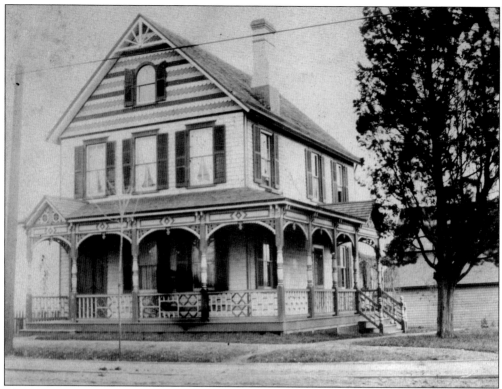

This November 22, 1898, image shows the ornate home of Frances Partridge, the widowed mother of May and Jennie Partridge. Frederick Partridge died in 1893 at 53 years of age. Frances was the daughter of Jane Mott and Elijah Sheddon, who died two years after his son-in-law. Jane subsequently moved in with her daughter and granddaughters. The house was located next to the home of the Sheppard family.

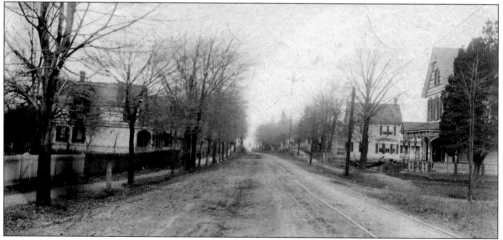

The railroad bridge on upper Main Street was the base for this November 22, 1898, view looking toward the downtown area. Although the Partridge home is visible at the right, the Sheppard and Pierson houses had not yet been built. Beyond the Partridge home, the house on the easternmost corner of what became Pierson Street is visible. The trees lining the street shield most of the other houses from view.

Seven

CODA

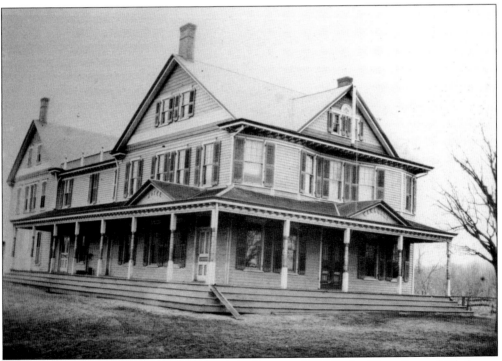

Charles Henry Manahan's hotel, near the intersection of Old Bridge Turnpike and Gladstone Drive, had one of the first telephones in the borough and was the clubhouse for the Middlesex Driving Park. Established in 1890, the hotel is shown here on March 6, 1897. It burned in December 1919. Manahan served as chairman of the East Brunswick Township Committee in 1886 and later as a South River councilman.

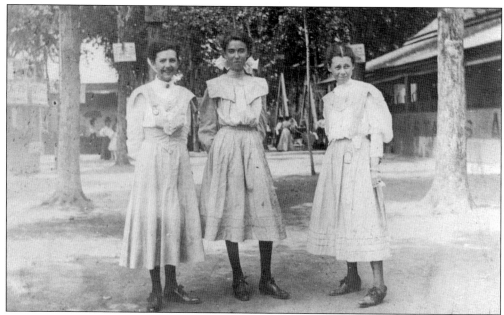

Alta May Price, Emma Parkinson, and Mabel E. Manahan were photographed together during a Sunday school excursion to Boynton Beach on August 5, 1905. All three girls lived on Main Street and remained single all their lives. Alta died in 1951, Emma in 1981, and Mabel in 1913. Mabel's father was Charles Henry Manahan. Her mother, Emma, and the Emma in the photograph were aunt and niece.

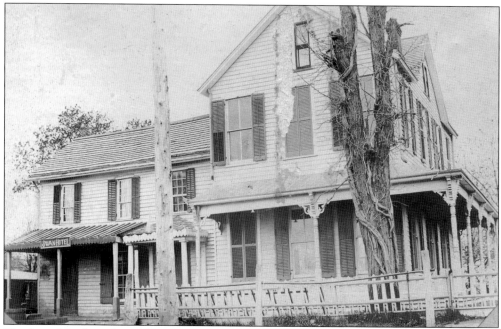

The Swan Hotel was located on the road to New Brunswick, later renamed Old Bridge Turnpike, in the area across from Tices Lane. It was a popular venue for meetings and social events, including shooting matches held at the rifle range on the property. Once known as Ryder's tavern, the building was destroyed by fire in 1875 and later rebuilt. The hotel is seen here on May 7, 1897.

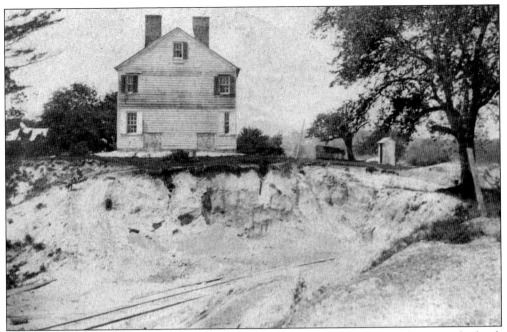

Located in the industrial north end of town, the old Garline Van Deventer house at the brick works operated by the Edgar Brothers Company is shown here on May 21, 1900. The property was included among those used to describe the boundaries of South River when it incorporated in 1898. The area became one of the most productive in the borough for mining and brick production.

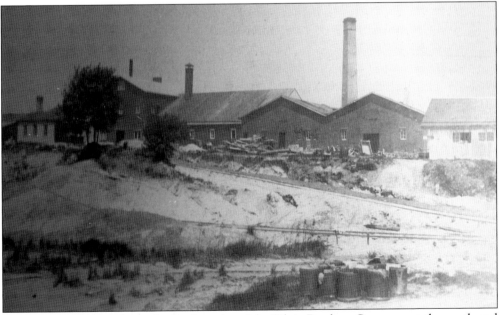

The complex that made up the brick works of the Edgar Brothers Company at the north end of town was photographed on the same day as the Van Deventer house, which also sat on the property. Sold to Robert W. Lyle in 1902, it became the Standard Vitrified Conduit Company and later the National Clay Manufacturing Company, Great Eastern Clay Company, and American Clay Products Company, employing over 200 people.

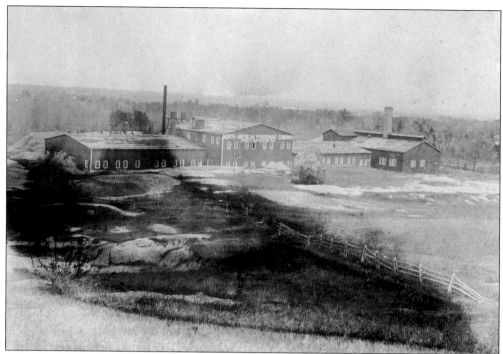

In 1891, after experts found clay on the Swan Hotel property that could be used for the manufacture of artificial granite, the North American Pyrogranite Company, later called the National Pyrogranite Company, was founded. Local investors, including Milton A. Edgar, built the plant seen in these photographs taken on May 7 and May 14, 1897. It was located in the area of lower William Street and Brick Plant Road. By 1908, the plant was bought by Robert W. Lyle, and the name changed to the Lyle Clay Company. They manufactured hollow building tile and later produced both fire paving bricks and bricks that were used to line furnaces, kilns, fireboxes, and fireplaces.

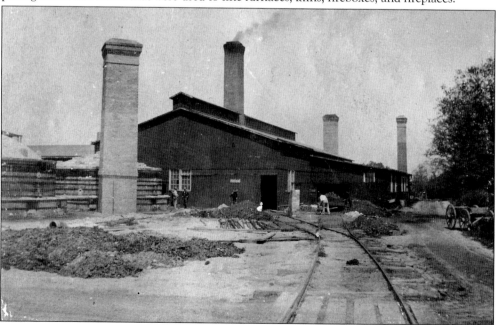

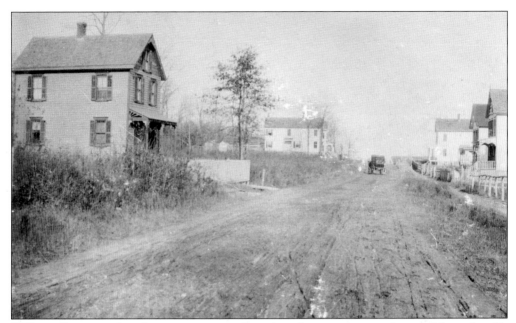

William Street was largely an open vista when this photograph was taken on November 21, 1898. Only a small number of houses are visible in this view looking north from Prospect Street. According to the 1900 census, most of the people who lived on the street during this period were employed at Pettit and Miller's brickyard. This included Joseph Miller, his wife, Mary, and their eight surviving children.

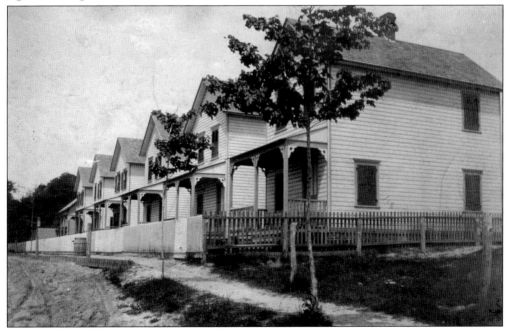

When it was photographed on May 21, 1902, Henry Street was part of the area that housed laborers for the local brickyard. The view sweeps westward from Maple Street toward William Street. This row of identical houses is typical of the tract housing that was built by many local industries for their employees.

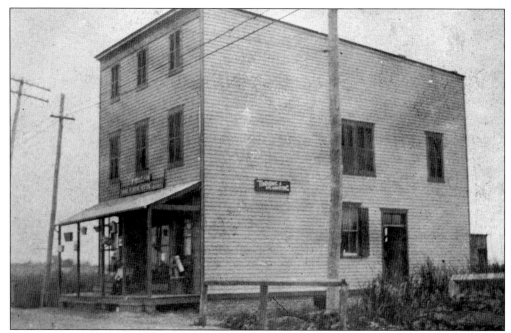

Smalley and Sons based its plumbing and tinsmith business in this shop on the Causeway, pictured here in July 1901. When the plumbers' union went on strike in 1905, William Smalley and his sons continued to work. An article in the *Daily Times* explains that "his sons are the only employees he has and they are members of the firm and therefore were unable to strike."

Jeanette Barclay Rogers, Marguerite "Maggie" Newman, and Carlotta Simonson came from different neighborhoods to pose for this July 1902 photograph. Jeanette, the youngest of the trio, lived on Main Street and was the daughter of grocer DeWitt Rogers. Maggie lived on the Causeway; her father, Joseph, was a painter. Carlotta's family lived on Reid Street, and her father, William, was a carpenter.

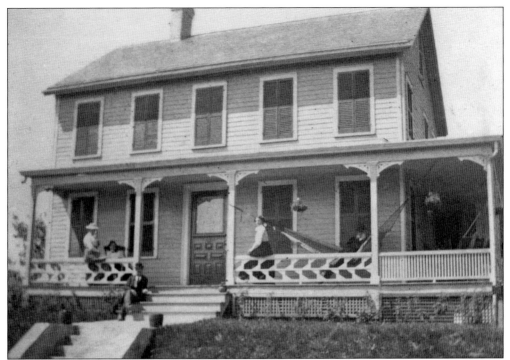

The residence of Joel C. Perry, pictured here on August 12, 1902, was located on Park Avenue. The large house had a balustrade decorated with leaf-shaped cutouts, as well as shutters that could be closed in the summer to block the sun while the louvers could be left open for ventilation. The porch featured two hammocks, and the side yard had a double-bench swing and an area for croquet. Perry also owned property on Main Street, where he ran a variety store for some years and rented space to his brother-in-law George Radcliffe. In later years, the neighborhood included African Americans from the South who came to work in brickyards and as domestic help. The Thomas Bell family rented a home, and Odell Allen, who was a cook for a chemical company, owned his home on the same street.

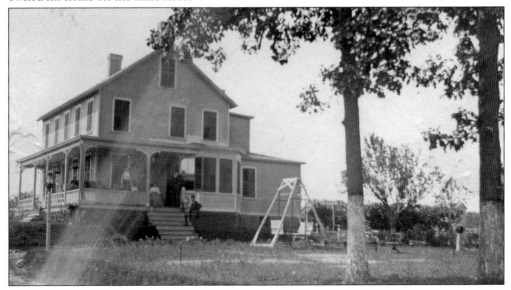

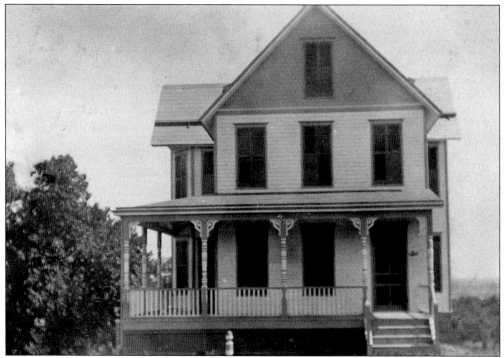

This image taken during the summer of 1904 shows the home of James E. Serviss on High Street, at the corner of Grove Street. Serviss was the brother of David Serviss, who lived on Main Street with his family. The two brothers married sisters. David married Mary Throckmorton in the 1880s, and almost 20 years later, in October 1904, James married Susan Augusta Throckmorton.

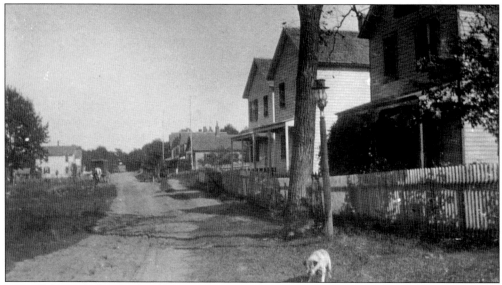

A small dog joined in for this photograph of Cemetery Avenue in a view looking east from Main Street on September 26, 1901. The Washington Monumental Cemetery gave the street its original name. Identified as New Cemetery Road when the 1900 census was taken, it later became Hillside Avenue. Among those who lived on the street in 1900 were the families of Charles Brusso, John Reinhardt, Anna Johnson, Frederick Werner, and Henry Schlegel.

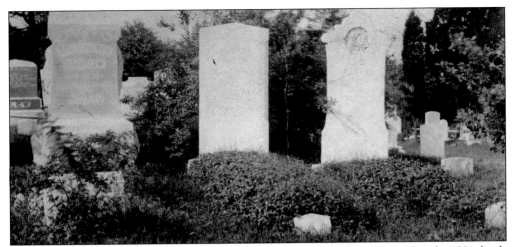

This photograph of the Reid plot was likely taken in the early 1890s, shortly after the 1891 death of Richard Van Dyke Reid's sister Gertrude Reid Barkelew. The stone at the left is hers. The remaining stones commemorate their parents, John R. Reid and Martha D. Snedeker. All three have since been replaced with more modern equivalents. A stone in the Blew family plot is just visible at the left.

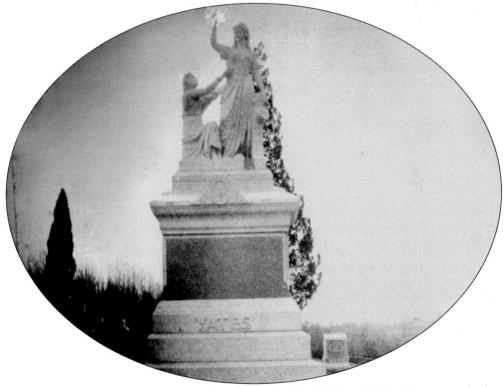

The Yates monument was photographed on December 16, 1898, long before the arm was broken off of the standing figure. The family was well known in the borough, and although some family members started off as boatmen, they went on to establish Yates Hall on Jackson Street as well as the Yates Brothers brickyard. William Yates, his wife, Anna M. Whitehead, and their three sons are memorialized on the monument.

In the foreground of this July 26, 1897, image is the Sperling family monument. Both Asher M. Sperling and his wife, Adaline M. Scobey, were still living when this view of the stone bearing their names was captured. Just beyond the fence is the property belonging to Clayton and Pierson's lumberyard, which burned just two months prior. The Herrmann, Aukam, and Company factory is visible in the distance.

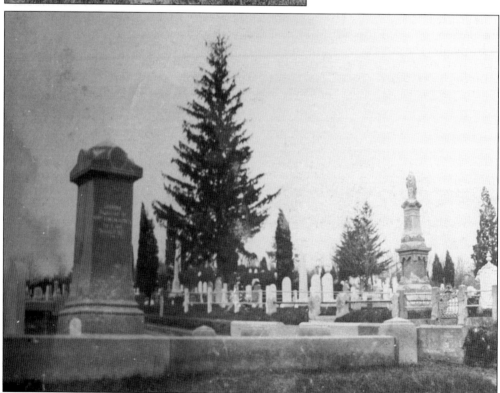

The large monument in the forefront of this image taken on December 20, 1897, belongs to the Stults family. On the other side of the cemetery roadway is the William Whitehead monument. The stones at the far left, along with many of those in plots near the Whitehead monument, have since disappeared or been replaced. The ornate stone at the right belongs to Jacob Charles Knaussmann, who died in 1870.

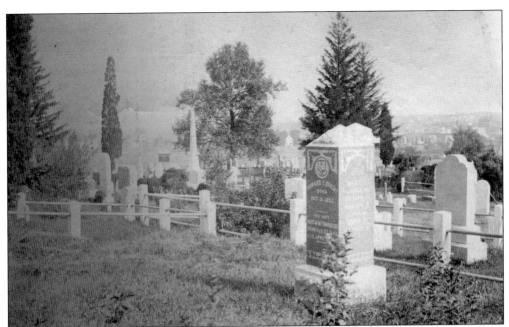

This undated cemetery view was taken near Hillside Avenue looking northeast. The stone in the forefront, ornamented with a Masonic symbol, memorializes Howard T. Bright and members of his family. The cemetery's central monument, located at the intersection between the four oldest sections of the cemetery, is visible left of center. In the distance, near the right edge of the photograph, is the Herrmann, Aukam, and Company factory.

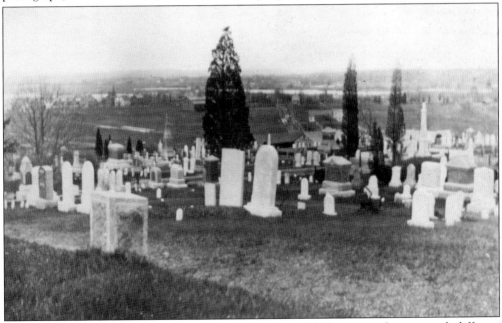

Taken from the highest point in the cemetery in April 1906, this image shows a much different South River than would be seen in the same view today. Clayton and Pierson's lumberyard is just beyond the cemetery, and the river is visible in the distance. An expanse of open land is also evident. In 1905, the population was 3,585; 100 years later, it was more than 15,000.

The 21st-century view of the south section of the cemetery, along Hillside Avenue, bears little resemblance to this October 13, 1898, image. The cross-shaped markers have all disappeared. The Blew monument, at the right, and the Hayes monument, near the leftmost tree, provide markers that place the photograph. In the distance, the distinctive cone-shaped stacks of the American Enameled Brick and Tile Company indicate the location of Whitehead Avenue.

The ornate archway and gate were still intact when the DeVoe family plot was photographed on September 26, 1901. The two matching headstones beyond the gate, commemorating Sarah Ann and James DeVoe, have since been replaced with a single, more modern substitute. The DeVoe family owned substantial property in the borough, and a street near the family home is named for them.

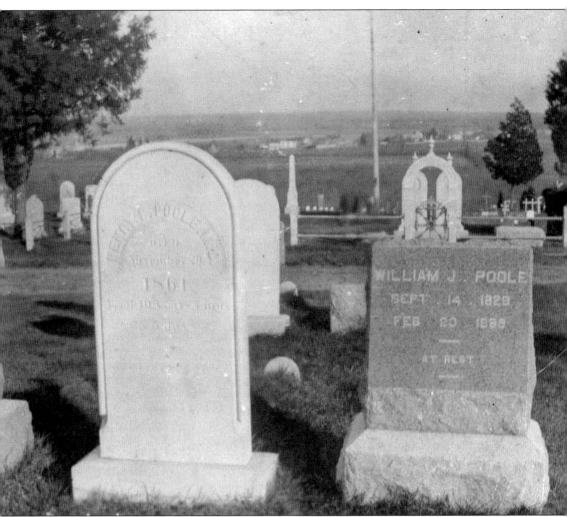

These gravestones are in the Poole family plot in Washington Monumental Cemetery. The entrance to the DeVoe plot is visible across the cemetery roadway in the background. The stones commemorate Henry B. Poole, MD, and William J. Poole. They were photographed on November 22, 1899, the year of William's death. Henry, born in England in 1790, was one of the first doctors in South River. He started his practice in 1832. A portion of his 1861 obituary reads, "For many years he was the Village scribe, and a surveyor, draughtsman, and in all other matters in which mathematical calculations were required, he was universally called upon for assistance and advice." An 1860s-era map of South River identifies the portion of Reid Street between Thomas Street and the bend near the river as Poole Street, perhaps in honor of the doctor who did so much for his adopted home. William was the son of Dr. Poole.

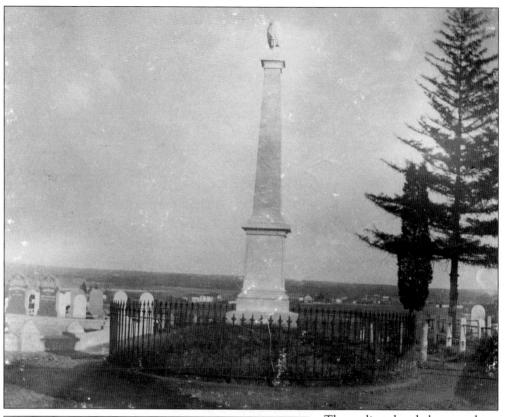

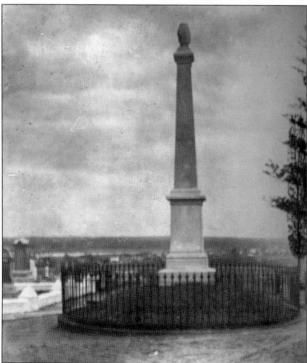

The earliest dated photograph in Richard Van Dyke Reid's collection (above) shows the central monument at Washington Monumental Cemetery on November 22, 1891. Among the last of his photographs is an almost identical view taken on April 16, 1906 (left). The cemetery corporation was formed on December 6, 1856. Carved on the four sides of the base of the monument are the name of the cemetery, information on its founding, a list of contributors, and a list of the first managers. The monument is topped by a carving of a cloth-draped urn, common in cemetery symbolism. The matching stones at the left edge of the older of the two photographs are those of John and Sarah Whitehead. The Martin plot is on the right.

BIBLIOGRAPHY

Alvarez, Ann. *East Brunswick and Its Mayors, 1860–2010.* New Brunswick, NJ: Lewis Scheller Printing, 2011.

Clayton, W. Woodford, ed. *History of Union and Middlesex Counties, New Jersey, with Biographical Sketches of Many of Their Pioneers and Prominent Men.* Philadelphia: Everts & Peck, 1882.

Schack, Paul. *History of South River, Commemorating the 250th Anniversary.* South River, NJ: South River Woman's Club, 1970.

Selover, Jesse, and Jean I. Selover. "History of South River, New Jersey." Unpublished manuscript, last modified 1963.

Snyder, John Parr. *The Story of New Jersey's Civil Boundaries, 1606–1968.* Bulletin 67. 1st ed. Trenton, NJ: Bureau of Geology and Topography, 1969.

South River Historical & Preservation Society, Inc. *Commemorative Book: in Celebration of South River's 275th Anniversary, 1720–1995.* South River, NJ: South River Historical & Preservation Society, Inc., 1995.

South River, NJ, Anniversary Committee. *200th Anniversary of South River, NJ, September 24–25, 1920.* South River, NJ: Spokesman Print, 1920.

Wall, John P., and Harold E. Pickersgill. *History of Middlesex County, New Jersey, 1664–1920, under the Associate Editorship of John P. Wall and Harold E. Pickersgill, Assisted by an Able Corps of Local Historians. Historical-Biographical.* New York: Lewis Historical Publishing Company, 1921.

DISCOVER THOUSANDS OF LOCAL HISTORY BOOKS FEATURING MILLIONS OF VINTAGE IMAGES

Arcadia Publishing, the leading local history publisher in the United States, is committed to making history accessible and meaningful through publishing books that celebrate and preserve the heritage of America's people and places.

Find more books like this at
www.arcadiapublishing.com

Search for your hometown history, your old stomping grounds, and even your favorite sports team.